DRAW LiKE AN ARTiST

100
CARTOON
ANIMALS

Brimming with creative inspiration, how-to projects, and useful information to enrich your everyday life, Quarto.com is a favorite destination for those pursuing their interests and passions.

© 2022 Quarto Publishing Group USA Inc.
Text © 2022 Keilidh Bradley

First Published in 2022 by Quarry Books, an imprint of The Quarto Group,
100 Cummings Center, Suite 265-D, Beverly, MA 01915, USA.
T (978) 282-9590 F (978) 283-2742 Quarto.com

Quarry Books titles are also available at discount for retail, wholesale, promotional, and bulk purchase. For details, contact the Special Sales Manager by email at specialsales@quarto.com or by mail at The Quarto Group, Attn: Special Sales Manager, 100 Cummings Center, Suite 265-D, Beverly, MA 01915, USA.

10 9 8 7 6 5 4 3 2 1
ISBN: 978-0-7603-7576-1

Digital edition published in 2022
eISBN: 978-0-7603-7577-8

Design: Quarto Publishing Group USA Inc.
Illustration: Keilidh Bradley

Printed in China

DRAW LIKE AN ARTIST

100

CARTOON
ANIMALS

Step-by-Step Creative Line Drawing

A Sourcebook for Aspiring Artists and Designers

KEILIDH BRADLEY

CONTENTS

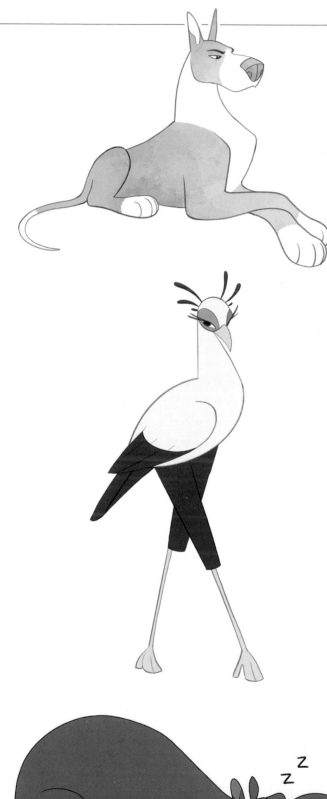

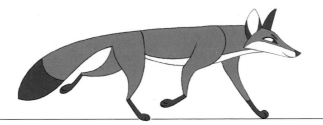

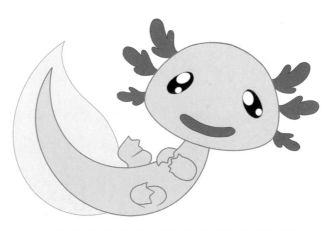

INTRODUCTION

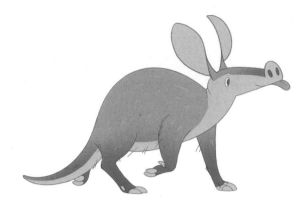

As a child, I had the great luck to have an aunt who produced natural history reference books full of beautiful drawings of African wildlife. She took me to the zoo when I was a toddler, then afterwards asked me to draw my favorite animal from the trip. That day sparked a passion for animal art that has sustained me ever since. They are by far my favorite subject matter and my most reliable source of inspiration. I first learned to draw by copying the illustrations in my aunt's books—far from their intended scientific purpose but it helped me develop the necessary observation skills and hand-eye coordination to later make my own original work. Therefore it's my greatest pleasure to help you develop your drawing skills.

HOW TO USE THIS BOOK

In cartooning, there are limitless styles available to draw in—the only limit is your imagination! Therefore, this book demonstrates a range of approaches to animal character design, from flat, graphic shapes to more realistic and dimensional construction. I recommend trying a few of the approaches to identify one you feel most comfortable with, then do more in that style. As you progress, you can take the skills learned from following one method to tackle more challenging animals.

Suggested Materials

I created the illustrations in this book using a digital drawing tablet and stylus. However, the approach translates well into traditional art with simple materials:

- Graphite pencil (HB preferred)
- Ballpoint, fineliner or felt pen
- Paper*
- Eraser
- Artist's Quality Marker
- Lightbox (Optional)

A Brief Note on Paper. Try to familiarize yourself with the weight (measured in lbs or grams per square meter [gsm]) of different papers and which feels most comfortable for you to draw on. Transfer paper and newsprint have a very low gsm, whereas cardstock is higher. A thicker or heavier paper will withstand the many steps in this process better than a thinner one, which might tear when erased or bleed through. While you work from this book, I recommend going no lower than 80gsm, which is the standard weight for printer paper.

Basic Drawing Process

Every drawing in this book begins with a rough sketch that is later cleaned up in the inking stage. Those working digitally can create a new layer for each step or keep steps 1-4 on a single sketch layer. If you're working on paper, draw your construction steps lightly in pencil. For step 5 of each illustration, use your pen to draw the final linework.

Option 1. Ink on top of your construction sketch. Let the ink dry for a few minutes, then erase the construction sketch. This option is best for heavier paper.

Option 2. Place your sketch on top of a lightbox, then add a fresh sheet of paper on top of that. Trace your sketch using your inking tool of choice. This takes the pressure off if you make a mistake, as your sketch is preserved and you can always try again with a new sheet of paper.

The Starting Point

STEP 1 STEP 2

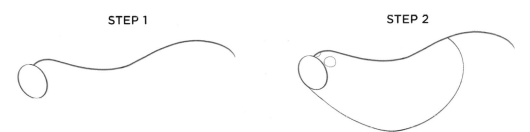

My approach as shown in Steps 1-2 is adapted from the drawing principle of *line of action*, sometimes known as the *gesture line*. This works great when drawing humans, but given how diverse the animal kingdom is, it isn't always the most suitable starting point. I generally prefer to define the head, chest, and rib cage as my first steps, because these are the most inflexible parts of most animals and serve as good markers for the rest of the body when placed correctly. The spine is good for defining movement and acting as a center line from which to add all other features. This isn't a hard-and-fast rule, so you'll see exceptions. It's important to be a flexible and creative problem solver when drawing animals—that's half the fun!

Completing the Form

STEP 3 STEP 4 STEP 5

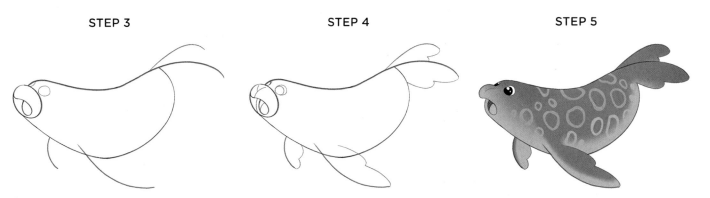

Working from big to small, Steps 3-4 define the most important shapes after the starting point. In land mammals and lizards, this is often the shoulder blades, hindquarters, and paws/feet. In sea creatures and birds, this might be the fins, wings, and feet. Correct placement of these features makes it easier to add contours and join different body parts together.

Adding Details and Inking

Step 5, the inking stage, is when we create the final linework. I've lightly included the construction sketch in every example in this book so you can see how to use it as a reference point. In simpler illustrations, such as the Chameleon (page 105), the steps are designed so you only have to erase a few existing lines to have your finished linework. In some examples, you won't have to erase any linework. In a more complex drawing like the Orangutan (page 37), you'll use the sketch as a reference point on which to drape fur and other details.

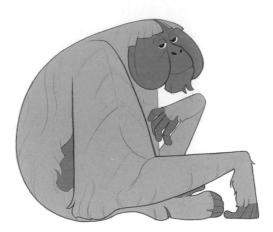

Coloring

Feel free to experiment with color! Look up reference images of the animals if you aren't sure which colors to use, or just pick your own—after all, your cartoons don't have to be realistic! To achieve the look of my drawings, you can:

If working traditionally, I recommend artist-quality markers. However, you can use graphite pencils, colored pencils, paint, anything! Whatever medium you choose, it's generally best to lay down the lighter shades first. Save markings such as spots or stripes for the very end. In most cases, you can add them using your inking tool after the base colors have dried.

If working digitally, create a new layer underneath the inking layer and name it "color." Use a "magic wand" tool to select the area outside of the line art—make sure there are no gaps in the lines beforehand. Then "invert" your selection and fill the area with a solid shade of gray, whichever best matches the one shown in this book. Lock the transparency of your layer and color.

TIPS FOR BETTER LINE CONTROL

TIP #1: DRAW WITH VOLUME

Drawing with volume isn't necessary for every style of cartooning. It's a technique I often use to depict a character that would be viewed in more of a 3D space rather than against a 2D plane; for example, a character designed for animation rather than graphic illustration. Visualizing volumetric shapes can then be very useful in every stage of the drawing, from building the basic shapes to placing the details. Construction lines help your character feel solid, believable, and real. In the Goldfish (page 70), I used volumetric lines to place the dorsal fin on the center line of the spine, then as a placement guide for his scales to depict his roundness.

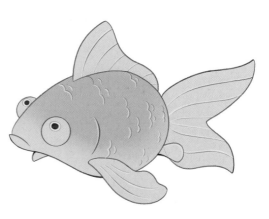

TIP #2: LINE CONFIDENCE

Try your best to draw with one unbroken line at a time. Develop your line confidence so that you can make clear, decisive drawings. Confidence will make your cartoons more convincing. I really believe in "economy of line"; that is, depicting the parts of a drawing in as few lines as possible. Take your time when copying from this book to develop this skill. It will be hard at first, but after 100 drawings you will be a far more confident draftsperson. Warm up by drawing circles and straight lines on a piece of scrap paper before tackling the illustrations. Draw over the same line or circle again and again while trying your best not to "break" the line.

TIP #3: LINE QUALITY

I sometimes use a thinner line for small details and a thicker line for large body contours. You can vary the width of your line by changing the pressure when drawing with a felt or ballpoint pen, or by building up the line with multiple strokes when using a fineliner. If drawing digitally, your pen may have a pressure sensitivity option that gives you the same effect. This attention to line quality will help keep from overwhelming the viewer's eye with too much visual information and creates an appealing contrast, which makes the drawing overall more interesting.

TIP #4: IMPLIED DETAILS

In cartooning, drawing every strand of fur or every scale on a creature can be far too overwhelming. I find it's better to imply these details with a few strokes at different points on the body, depending on the animal. For example, Penguins (page 87) have short and dense feathers so I only drew individual feather lines on the wings. The Macaw (page 82), however, has much larger and more obvious feathers, so I implied this with a few lines on the neck and wings. Take care to consider the underlying form when placing details; ask yourself whether the surface is round like a ribcage or more flat like an outstretched wing, so that you know whether there should be a slight curve to the line for that detail.

TIP #5: STRAIGHTS VS. CURVES

Straights against curves is a very common principle in character design. It creates visual contrast and helps simplify a form to its simplest shape. A line doesn't have to be rigidly straight to utilize this technique. In the Blue Whale (page 79), the underside has the fewest details, so I've simplified it to a mostly straight line, in contrast to the swooping curve of its head and back. This creates a nice visual rhythm to lead the eye around the drawing.

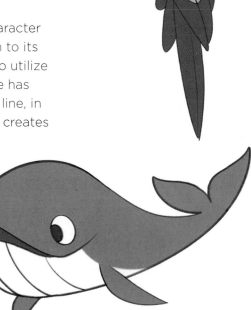

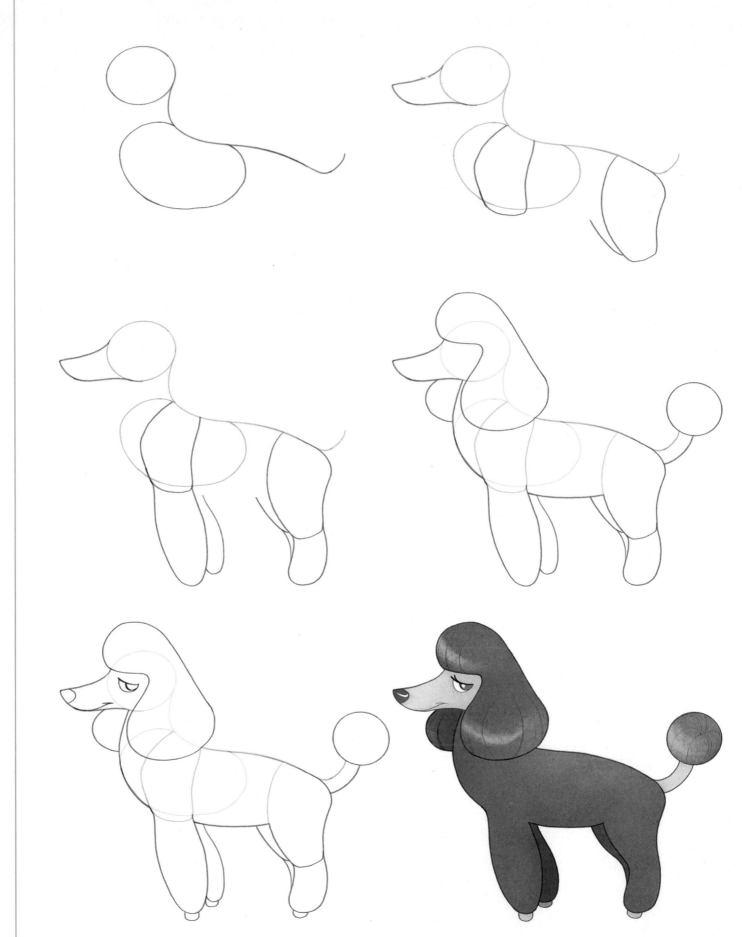

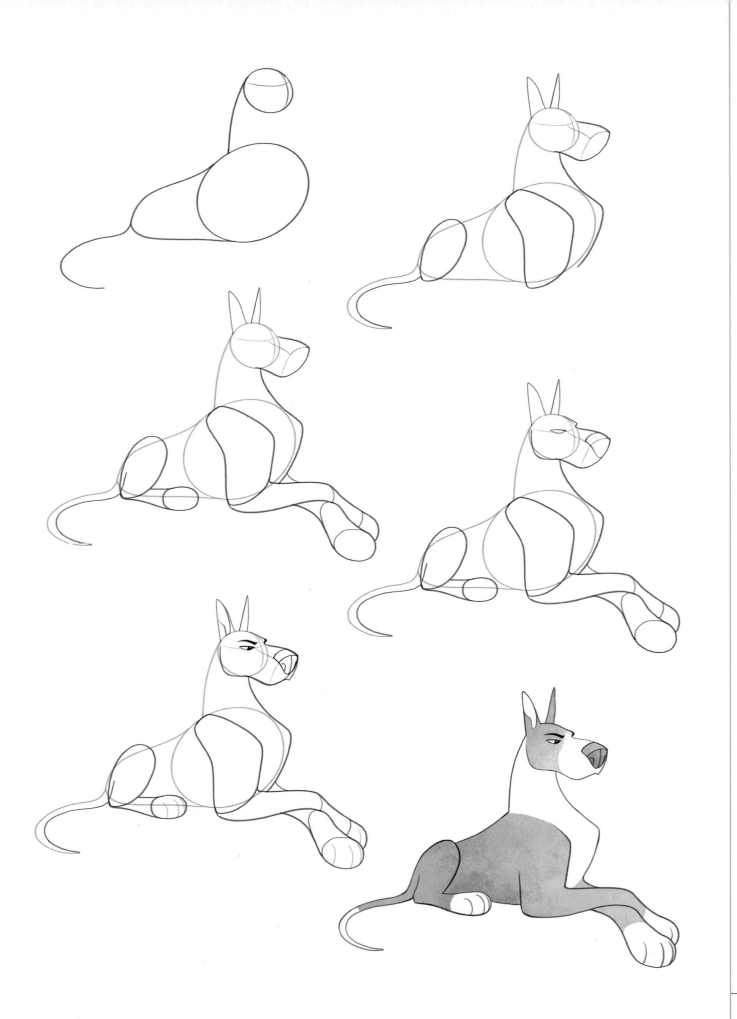

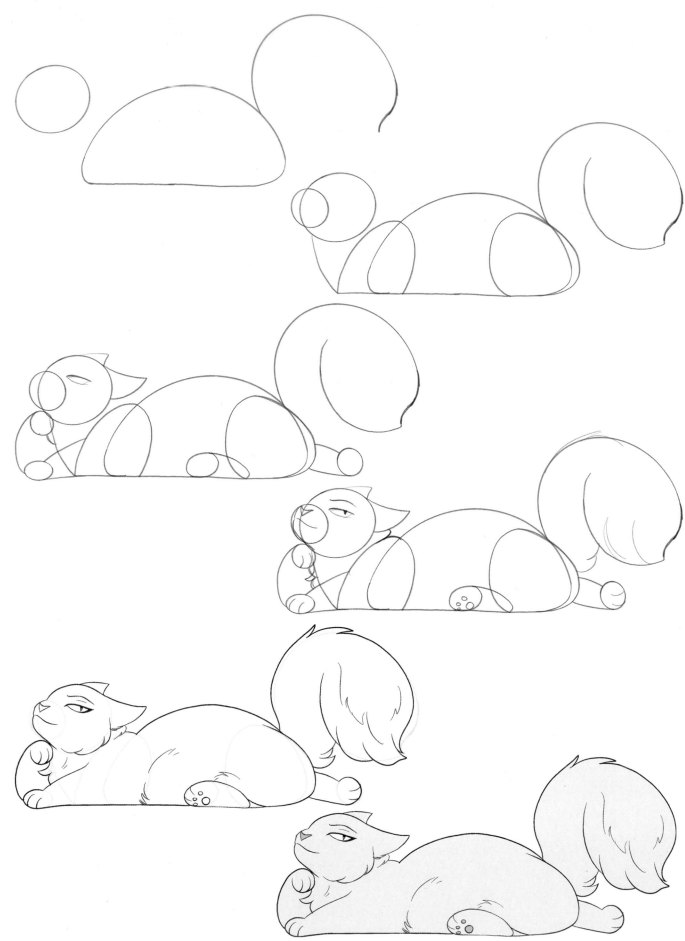

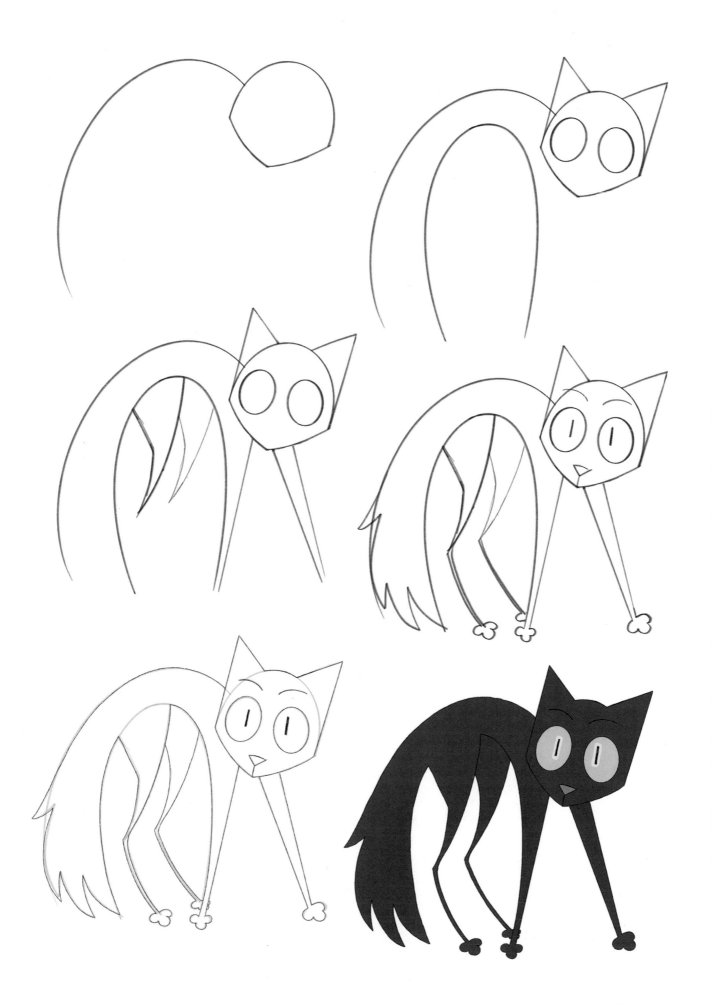

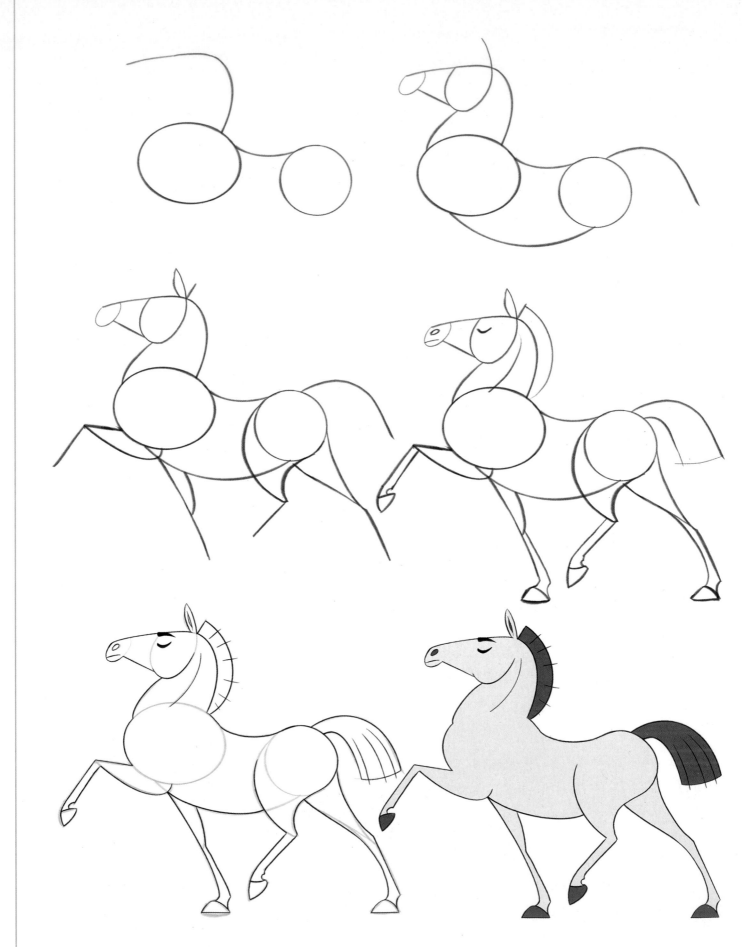

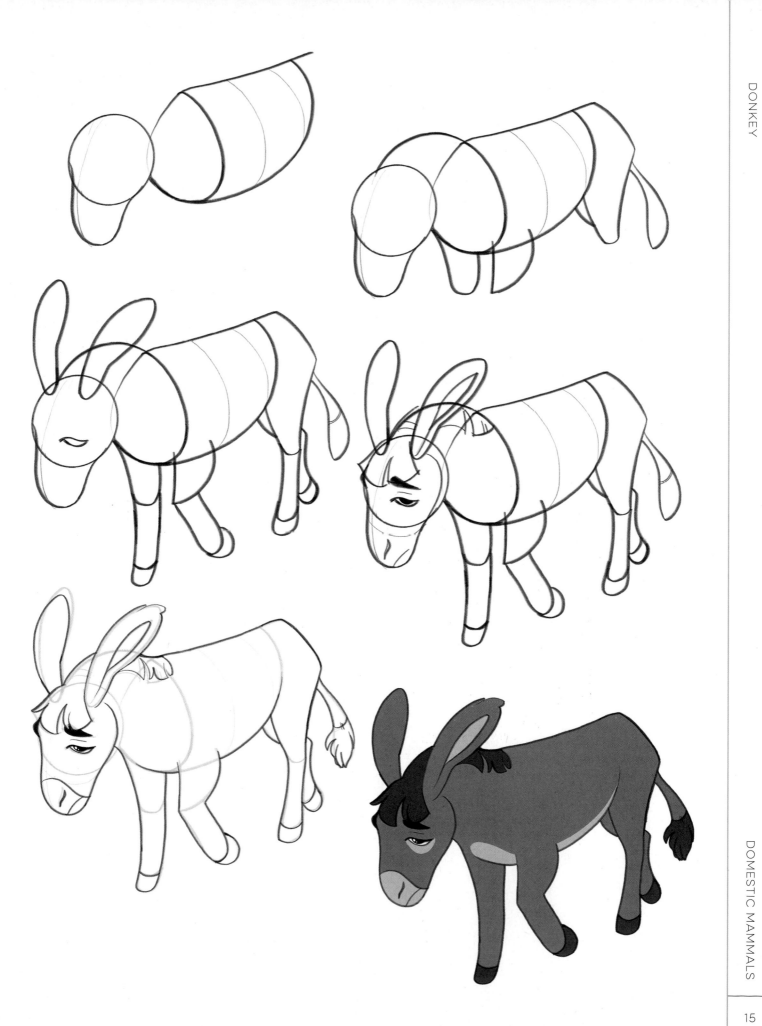

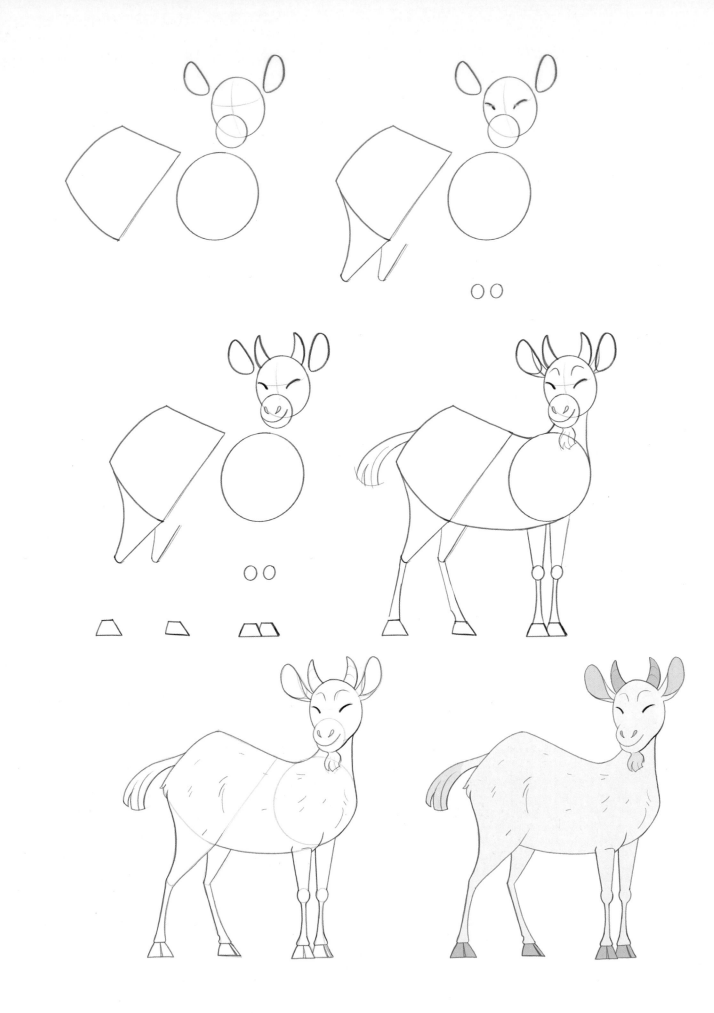

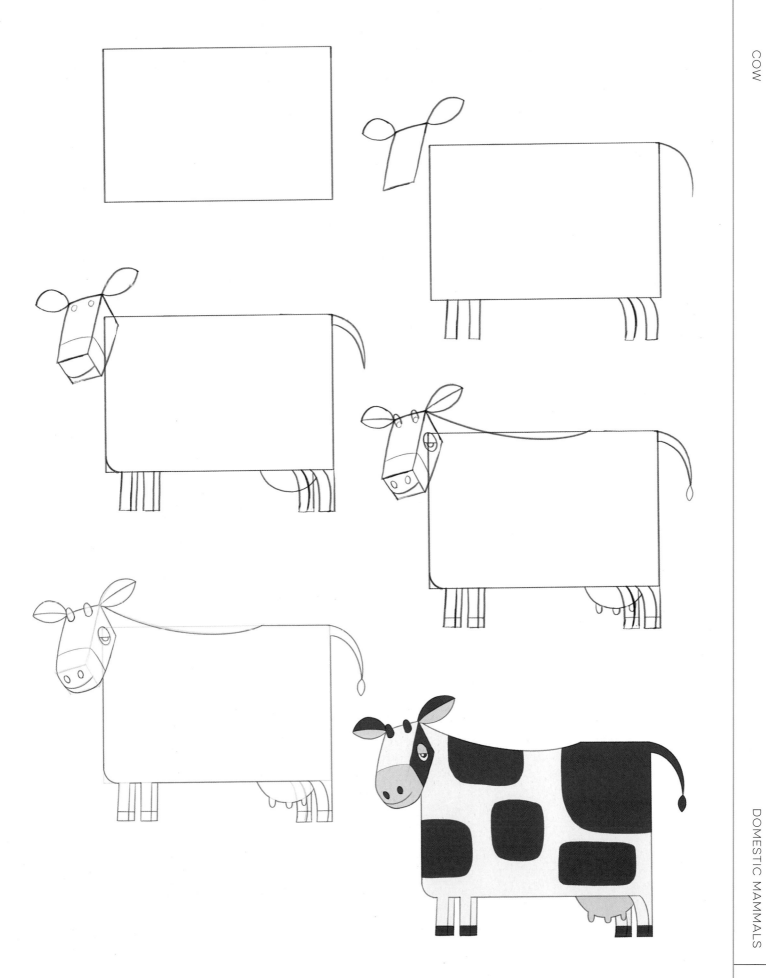

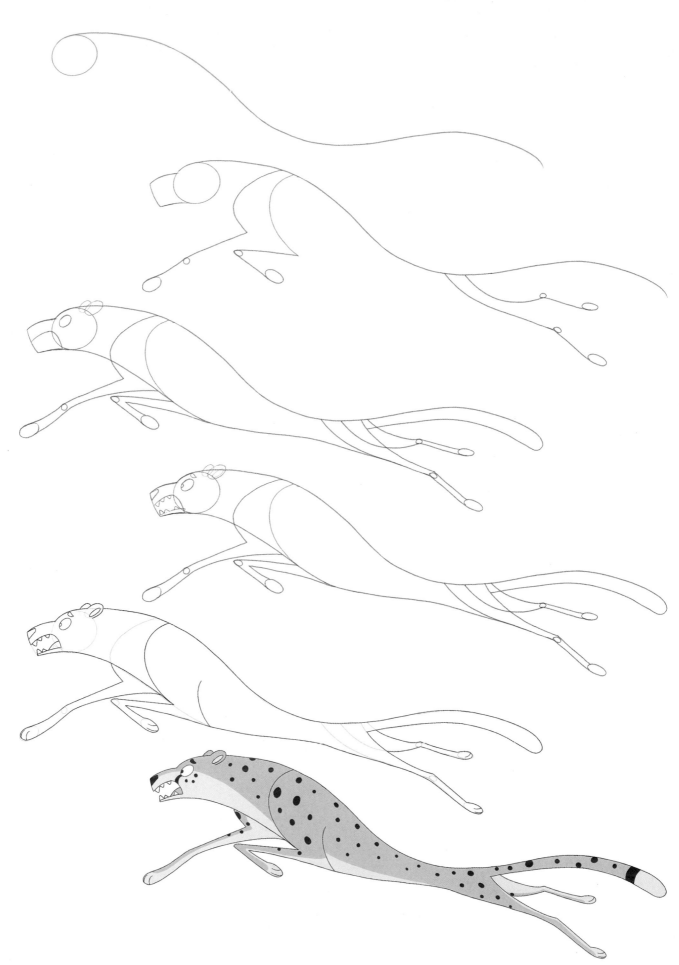

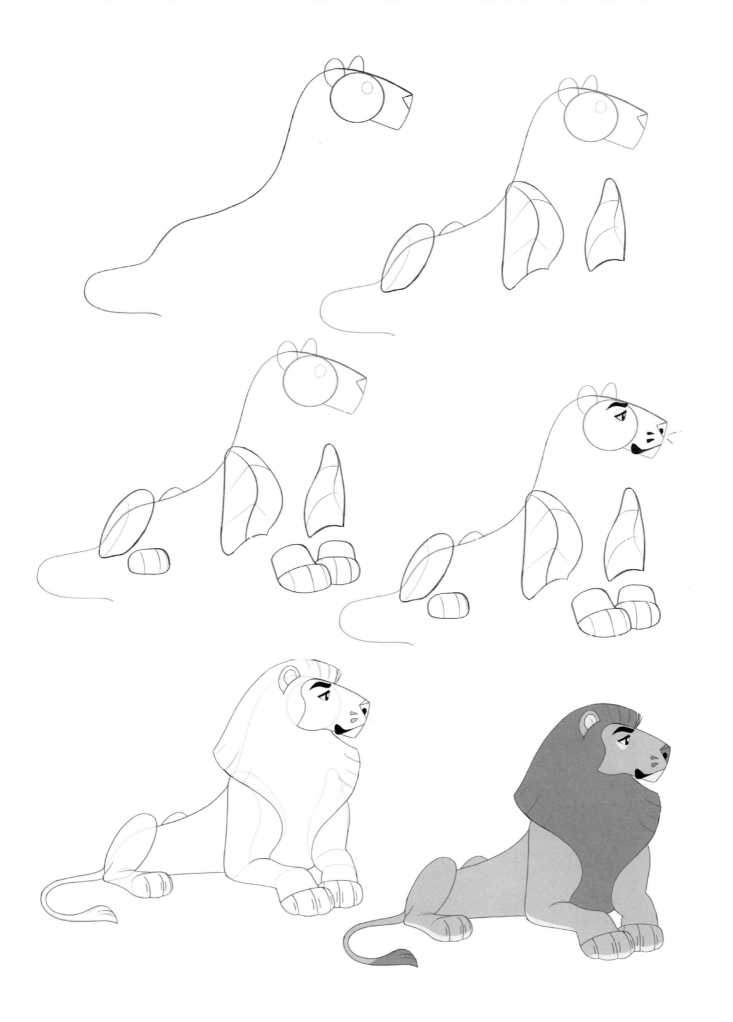

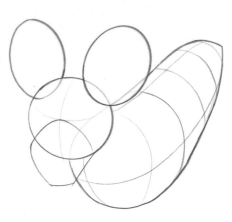

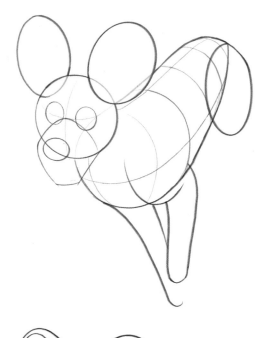

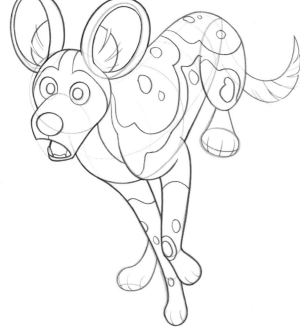

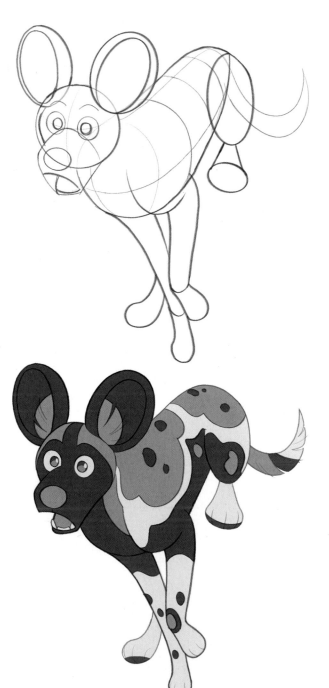

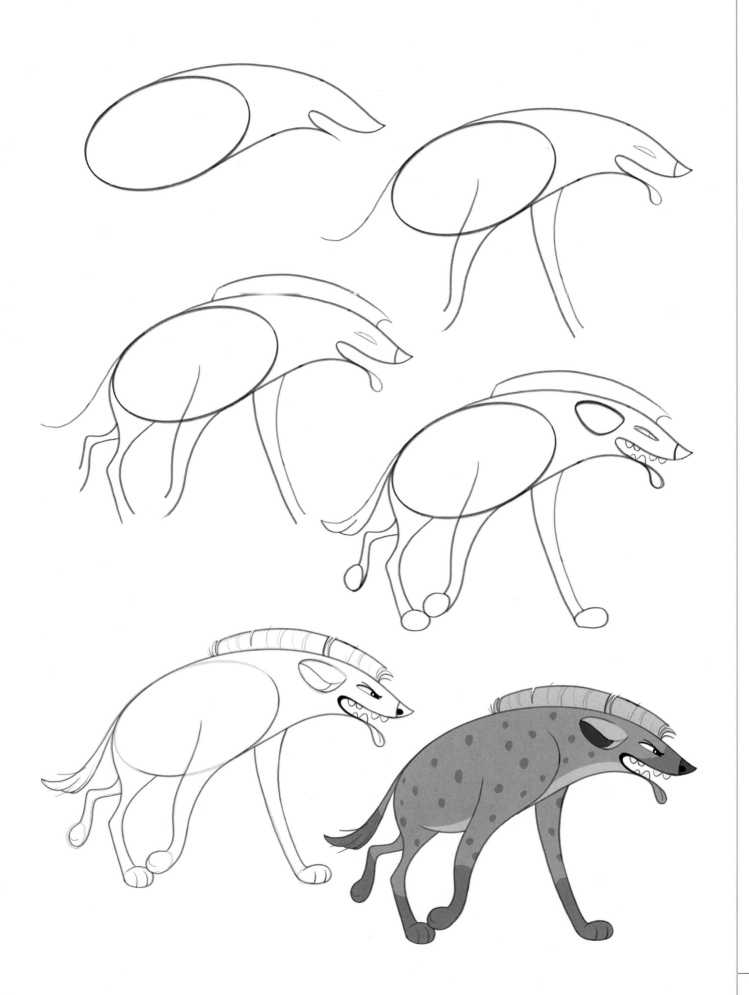

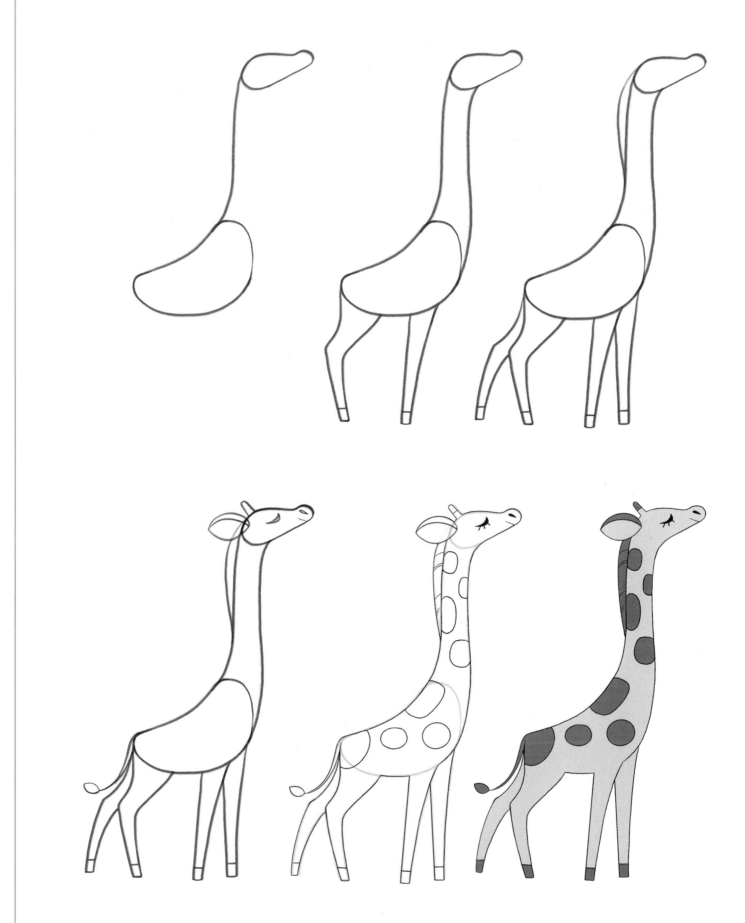

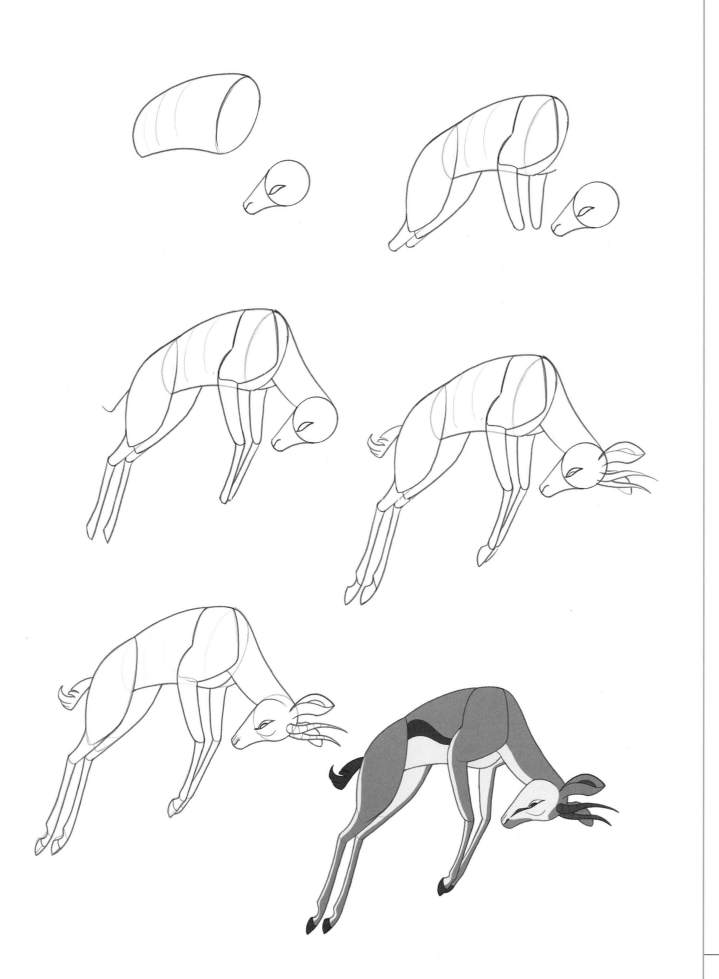

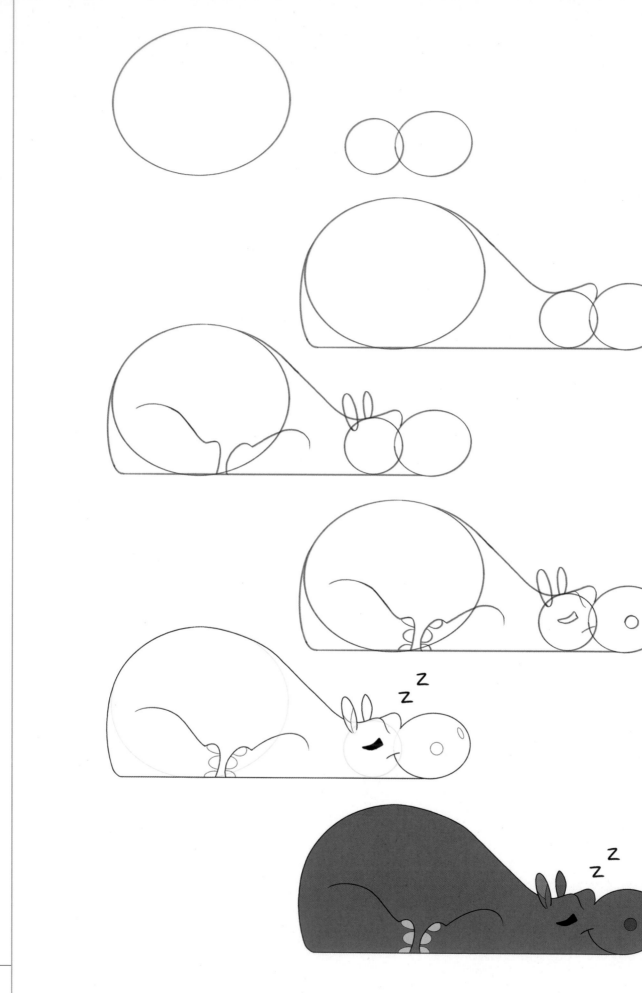

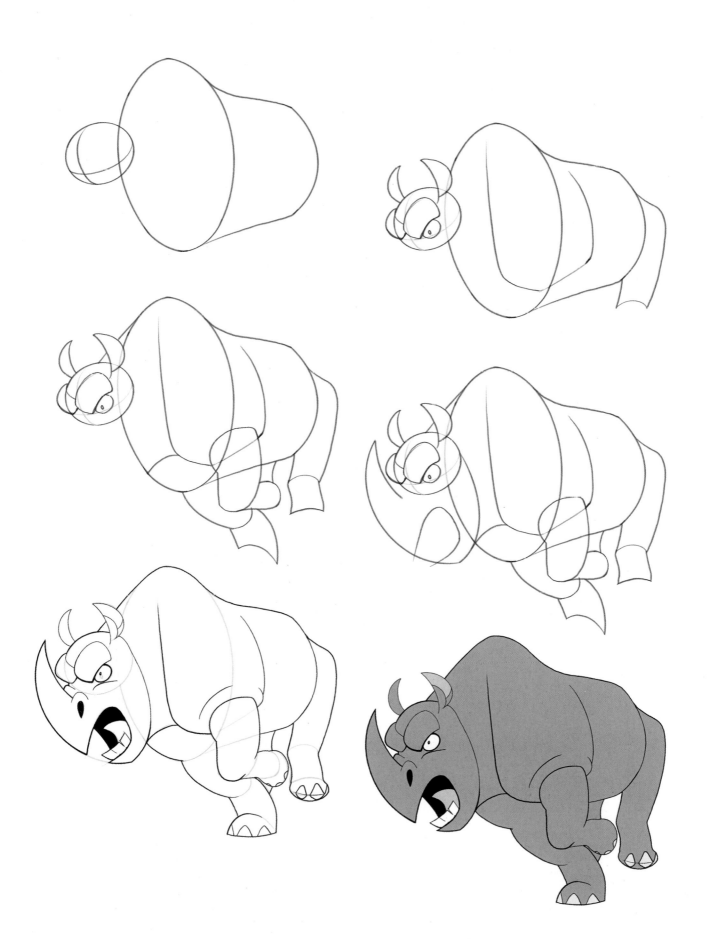

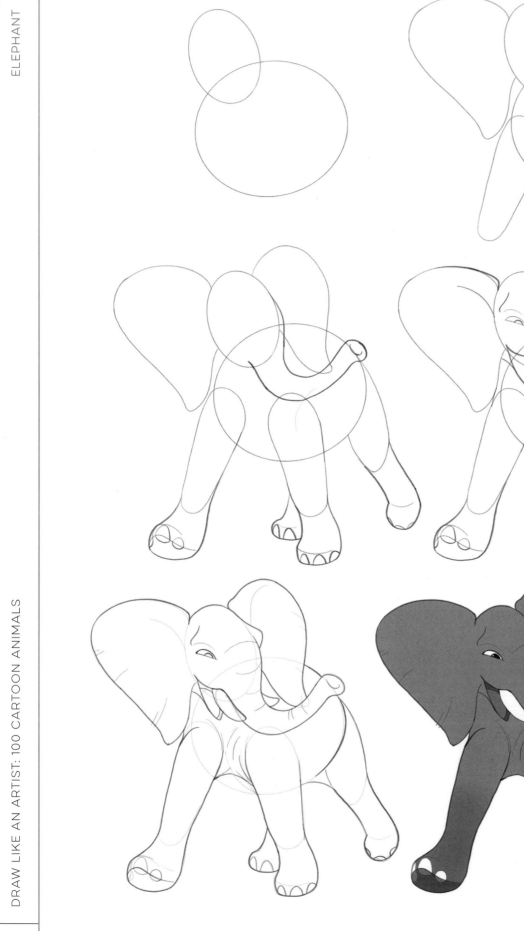

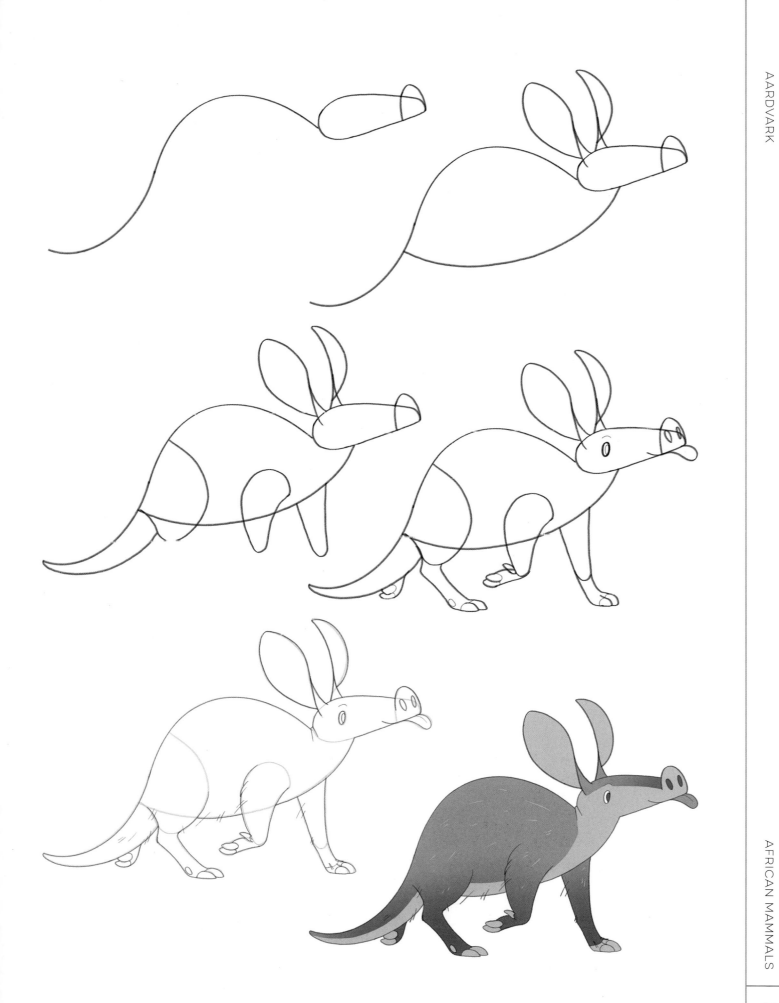

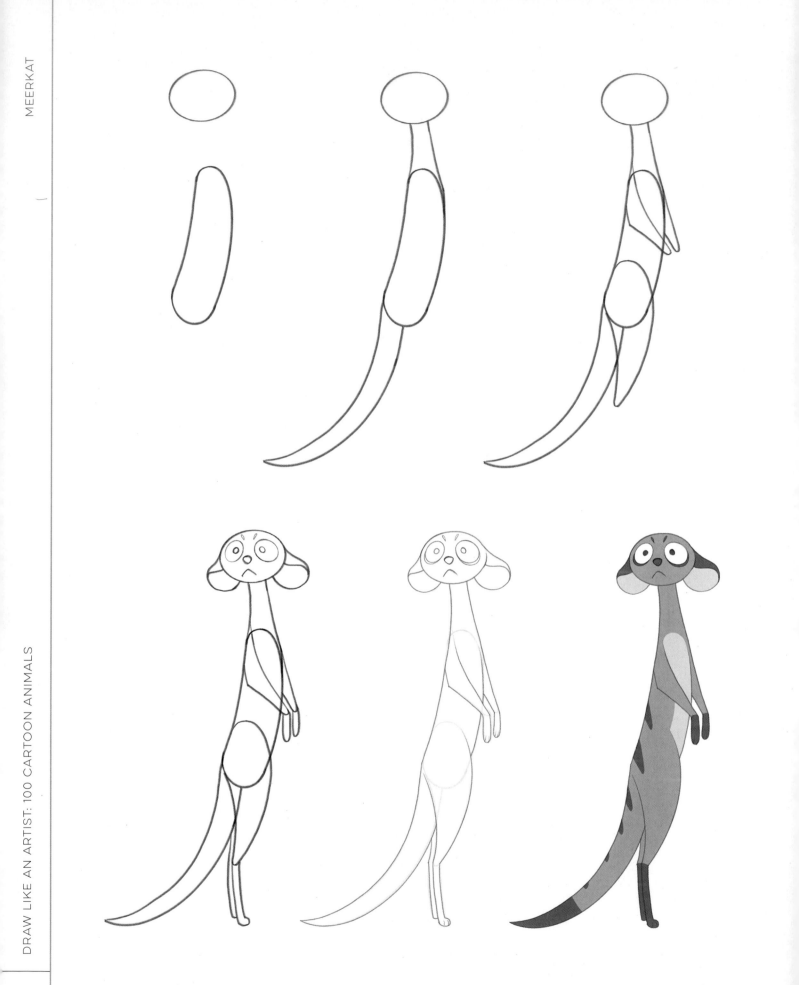

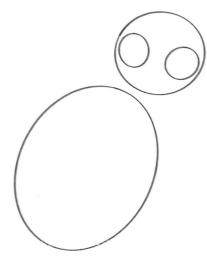
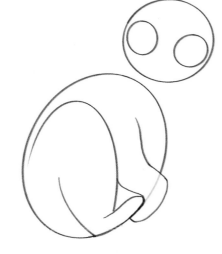

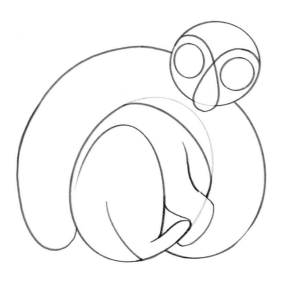
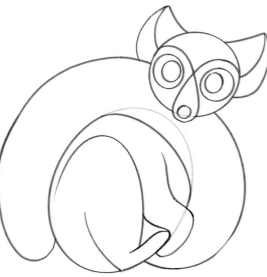

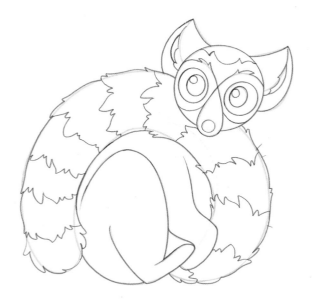
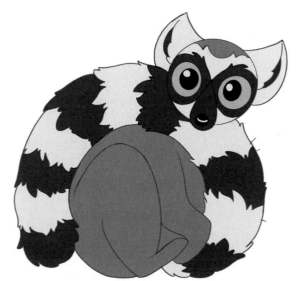

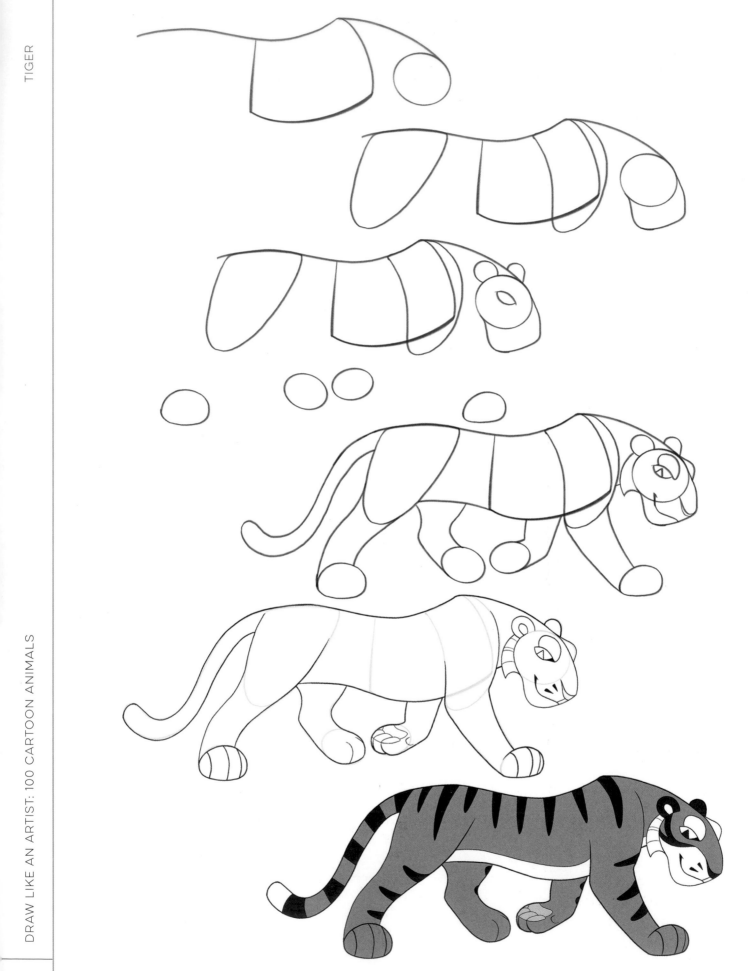

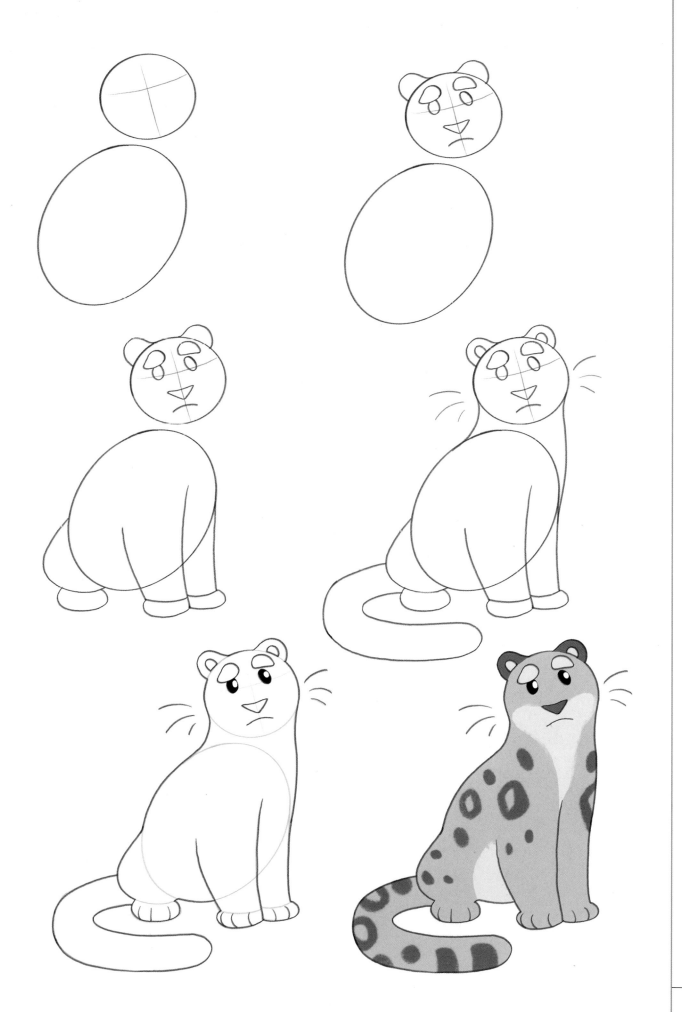

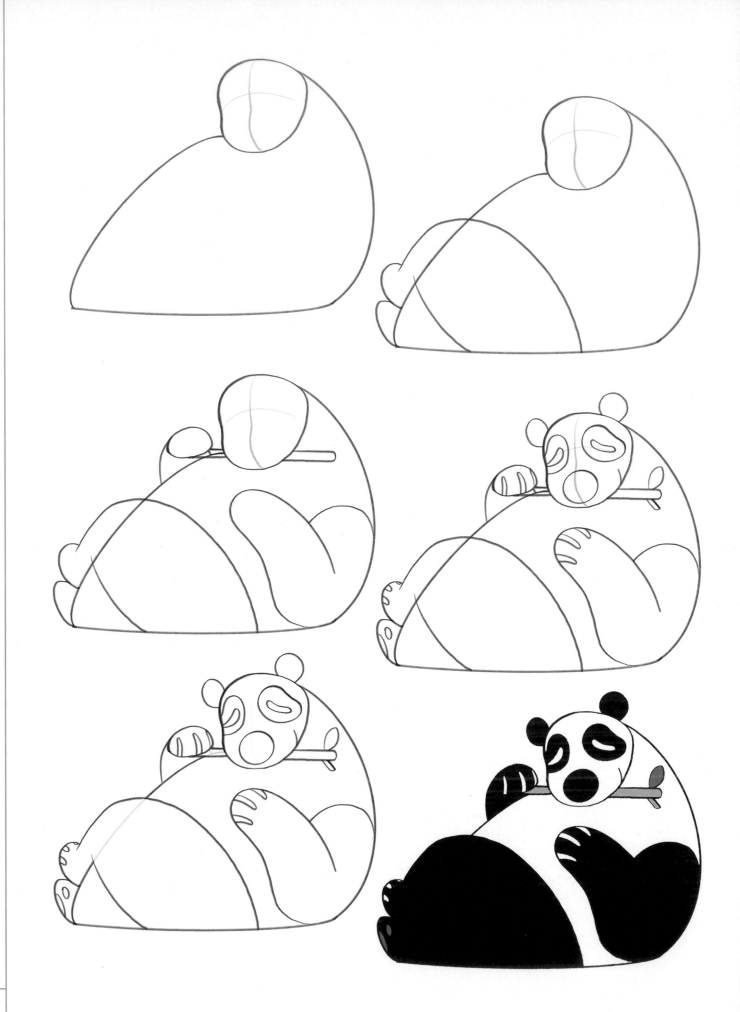

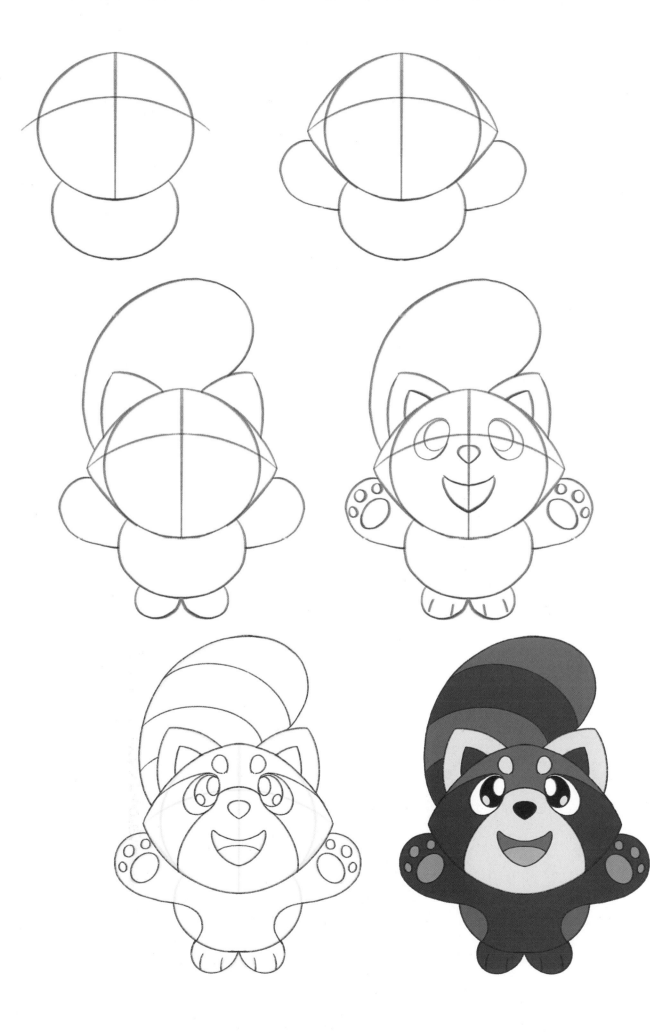

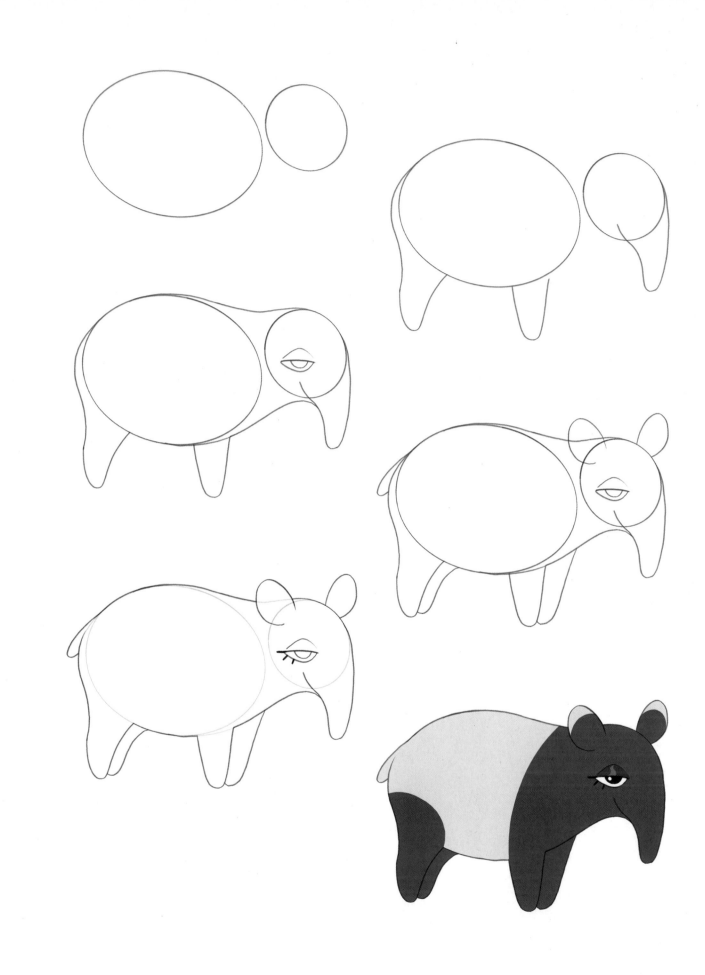

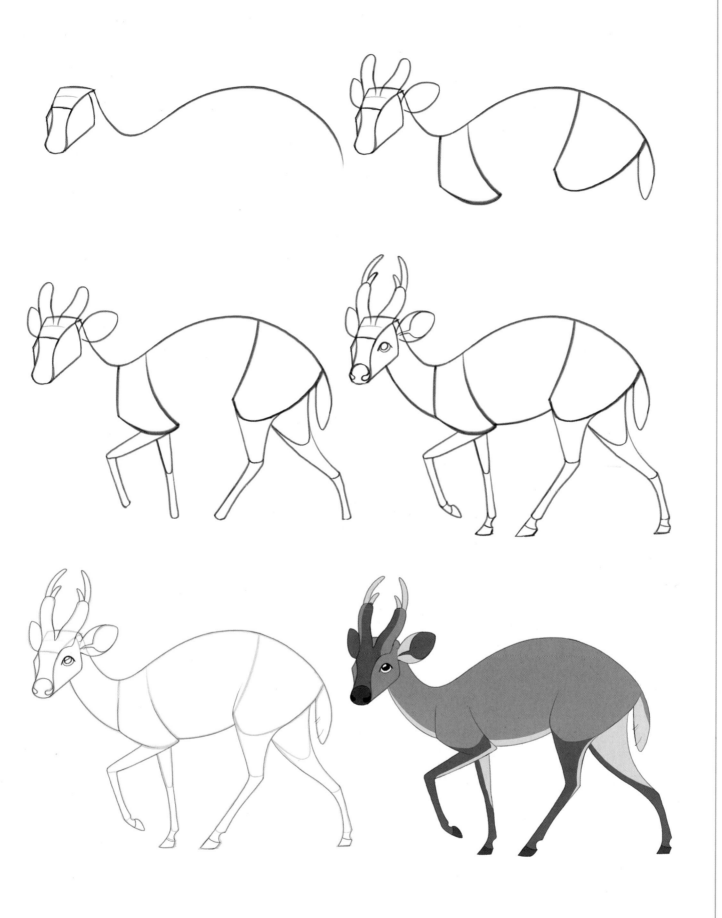

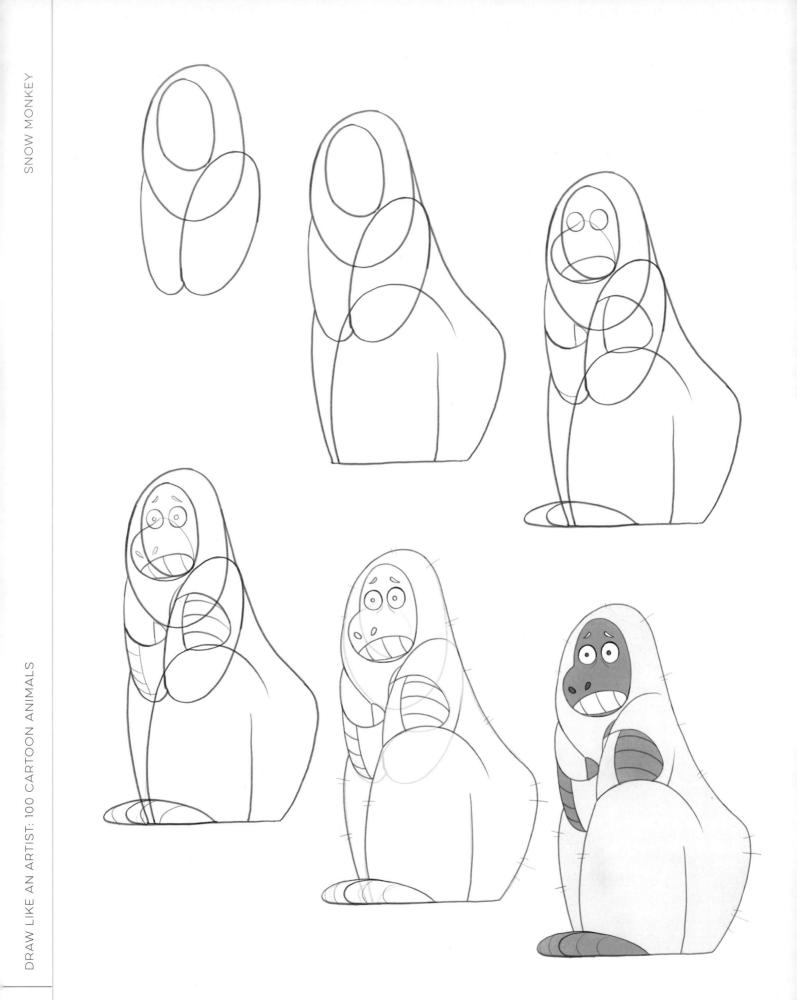

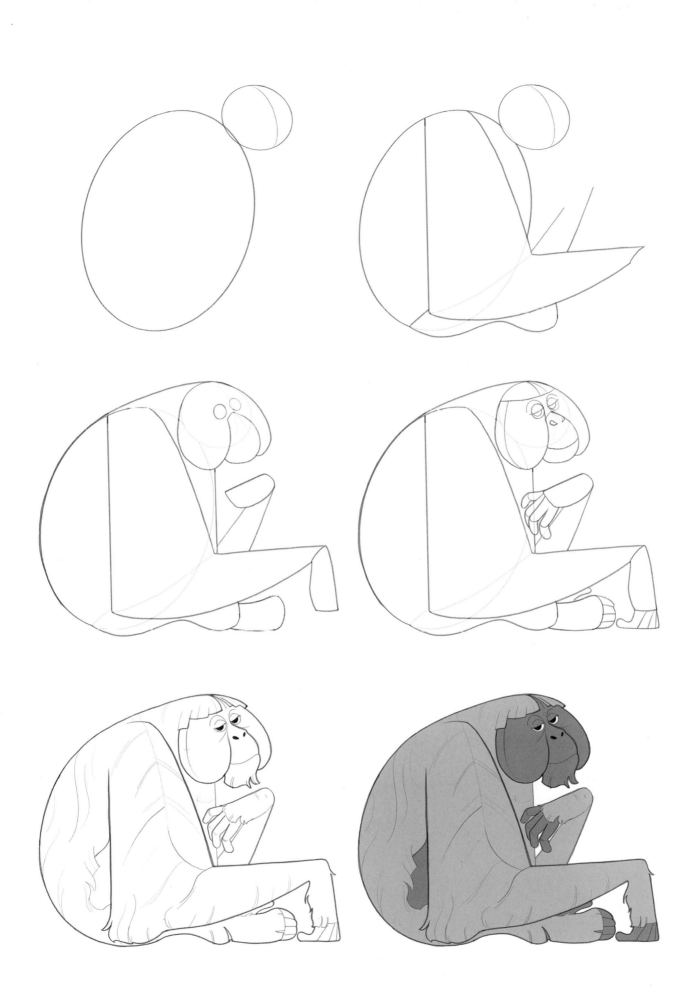

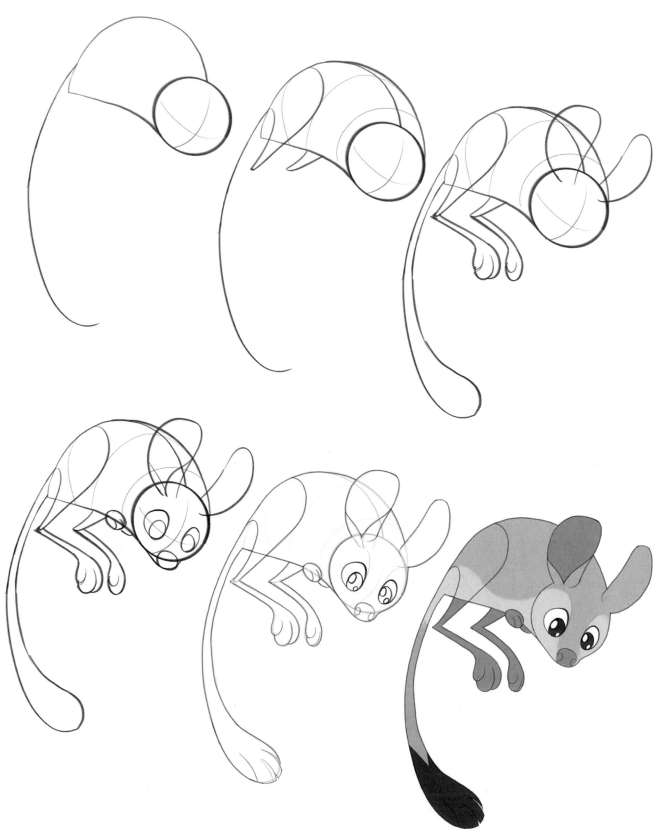

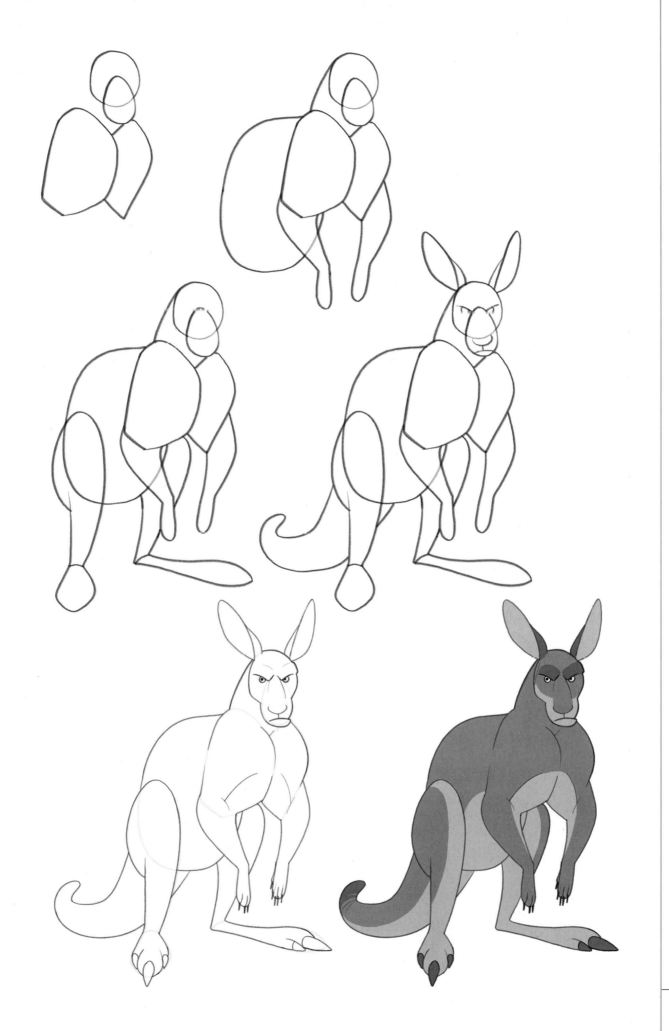

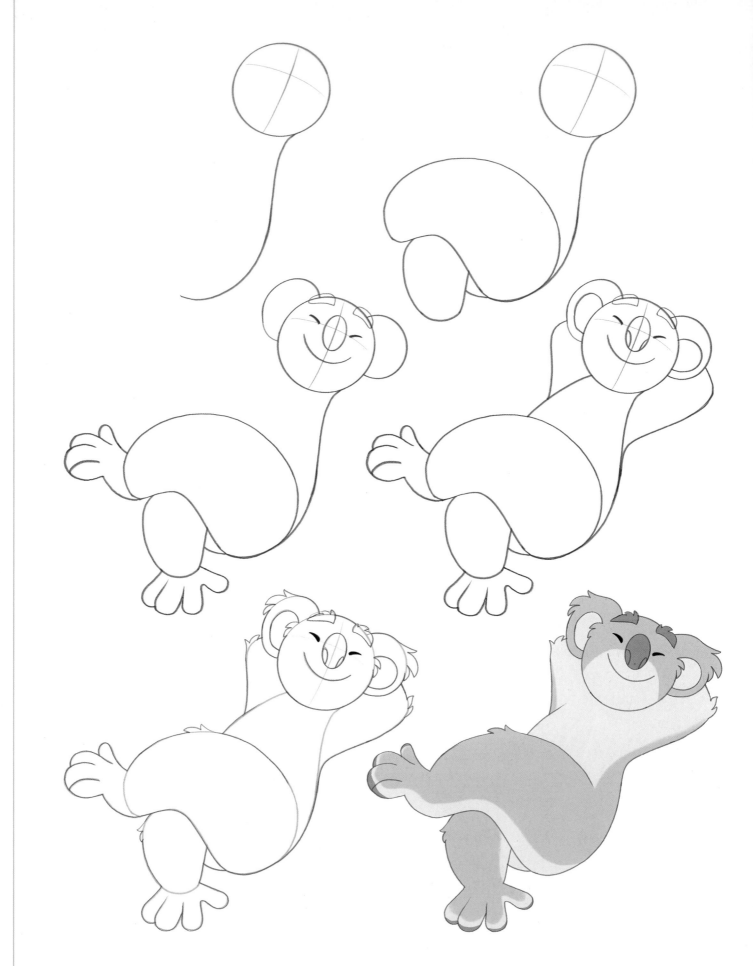

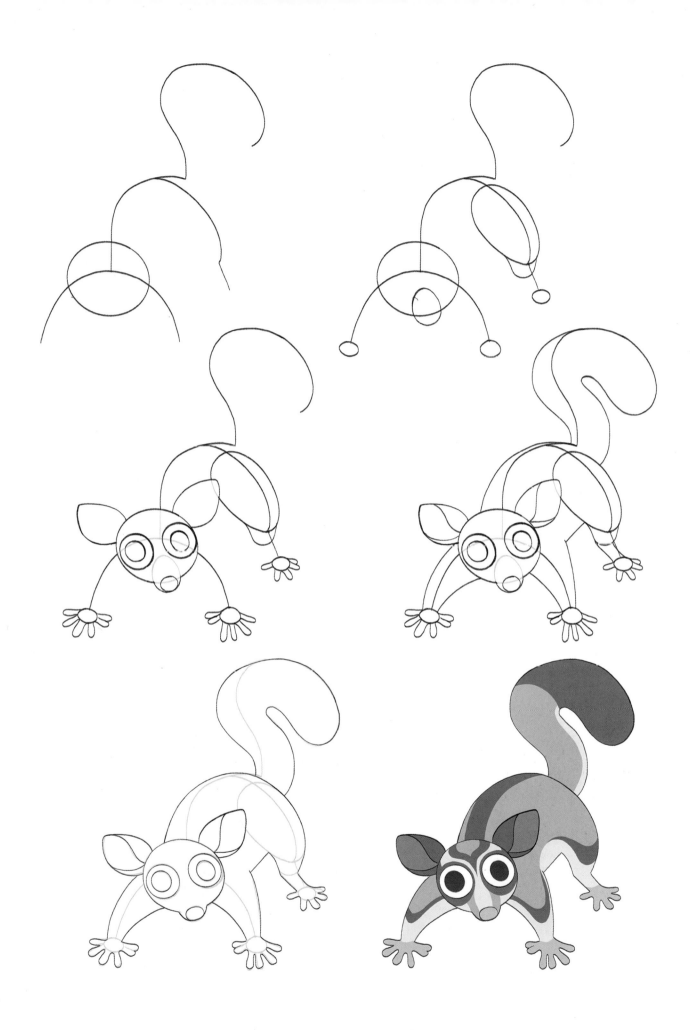

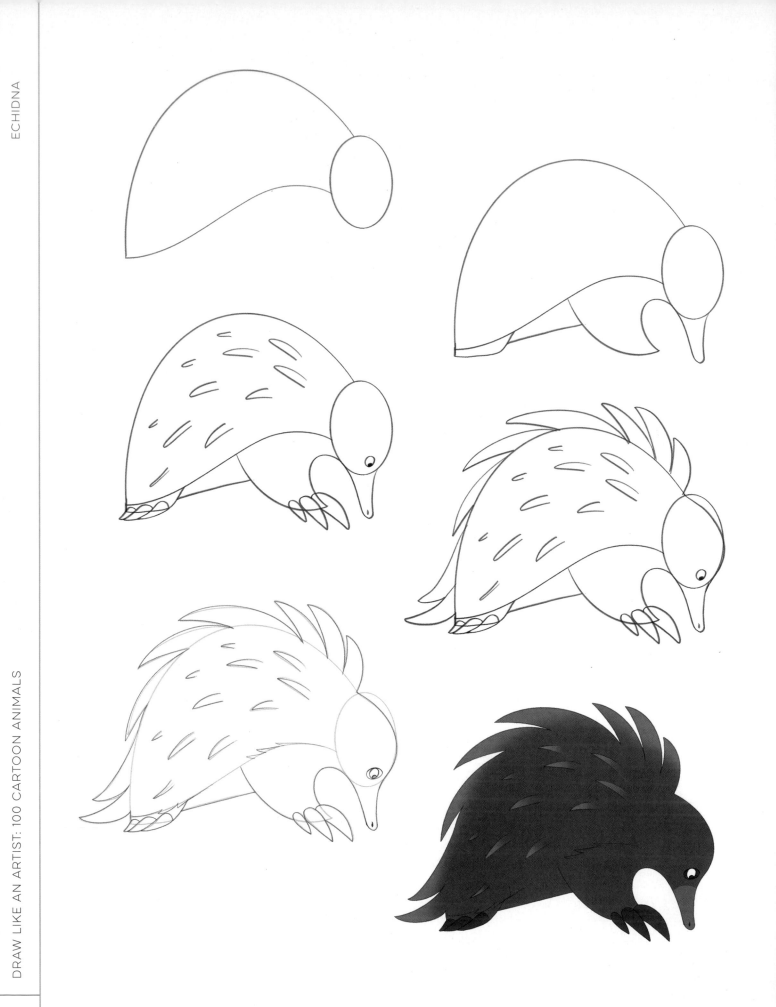

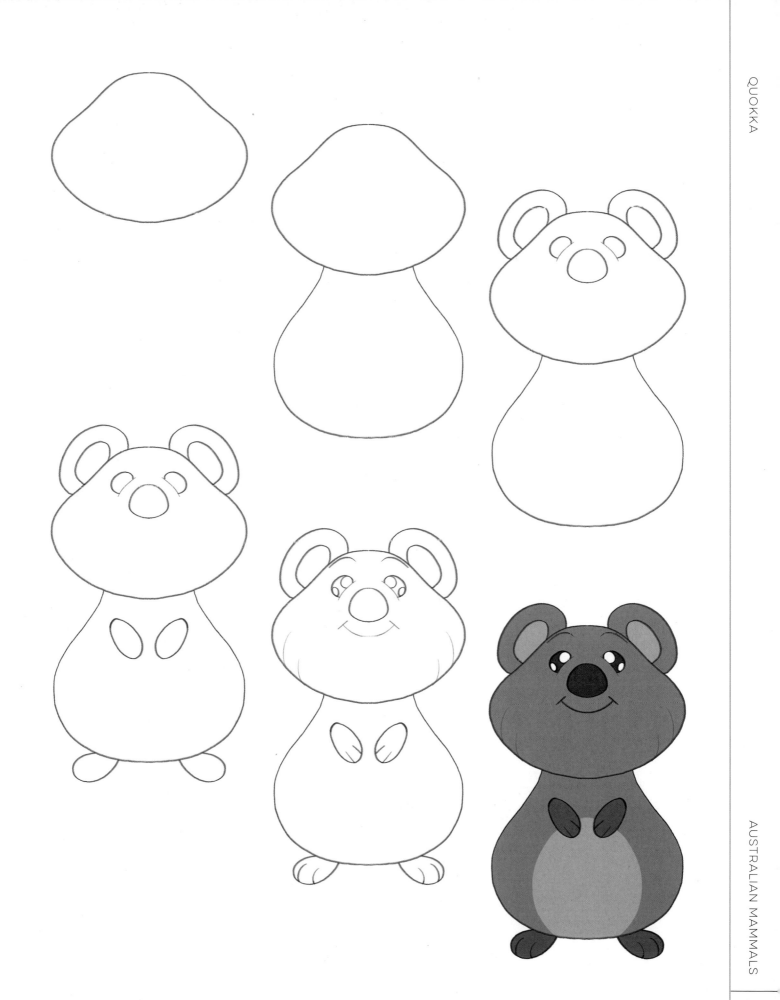

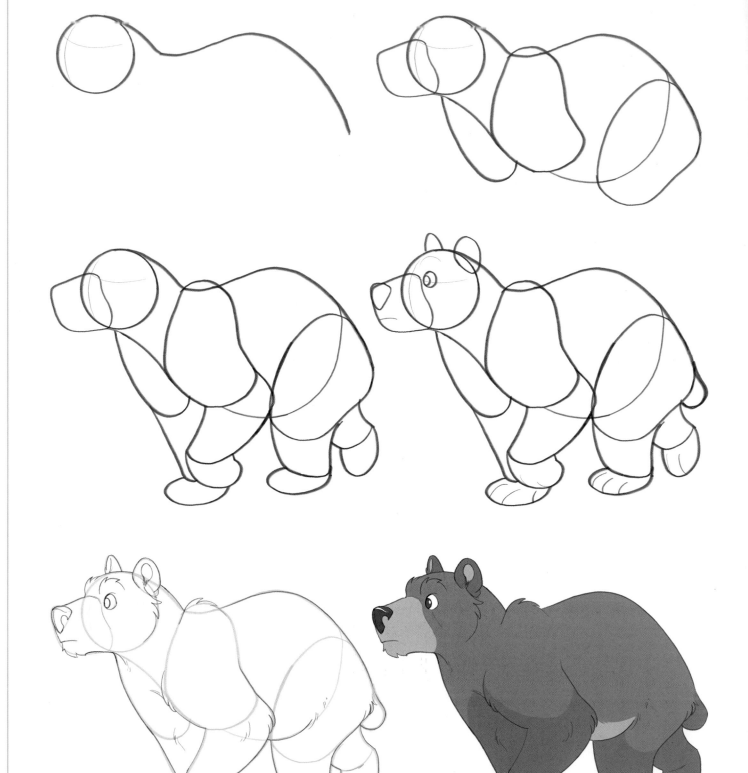

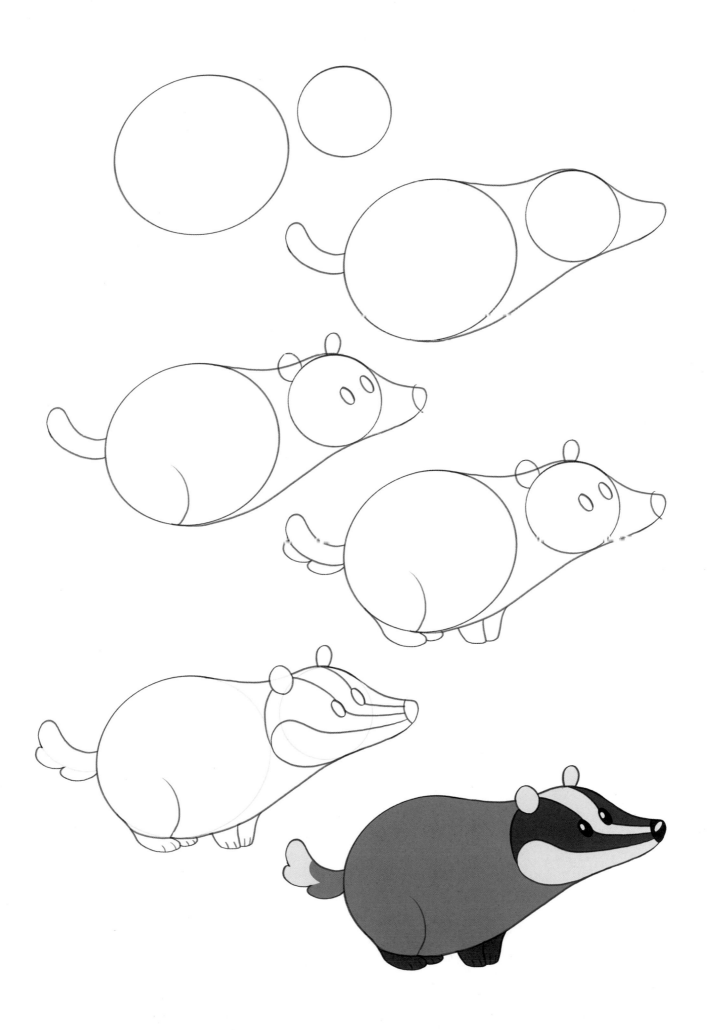

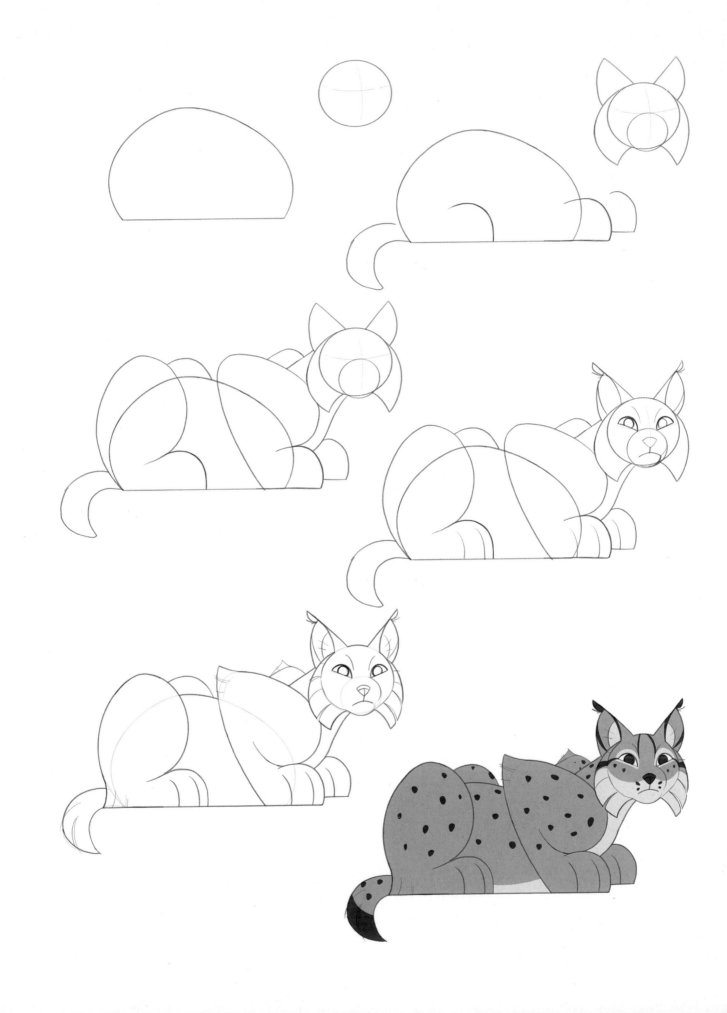

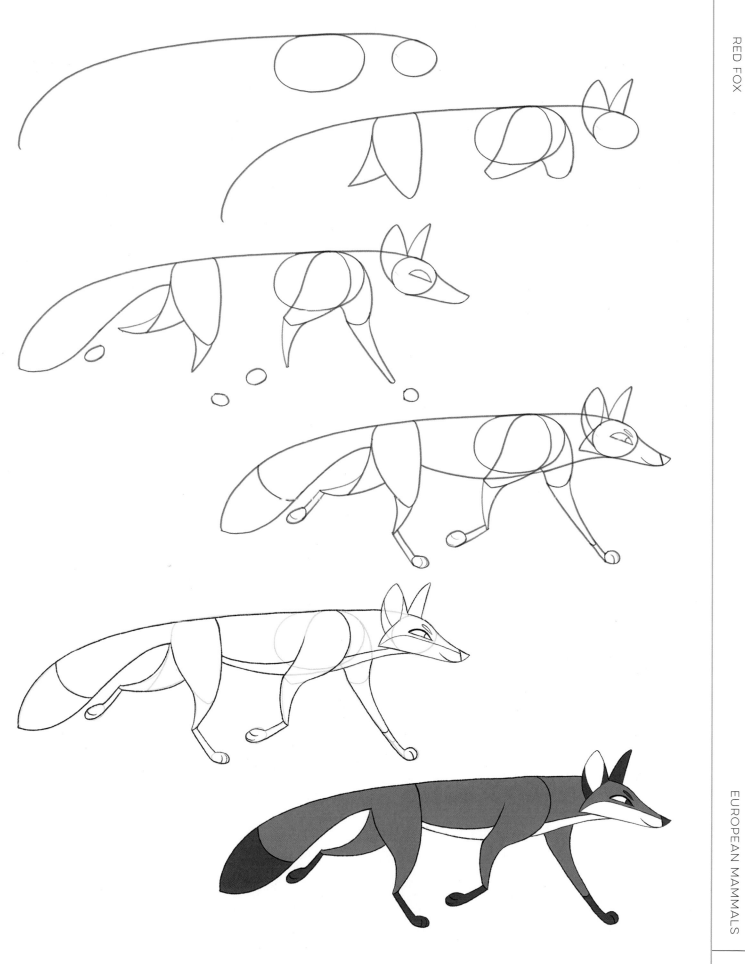

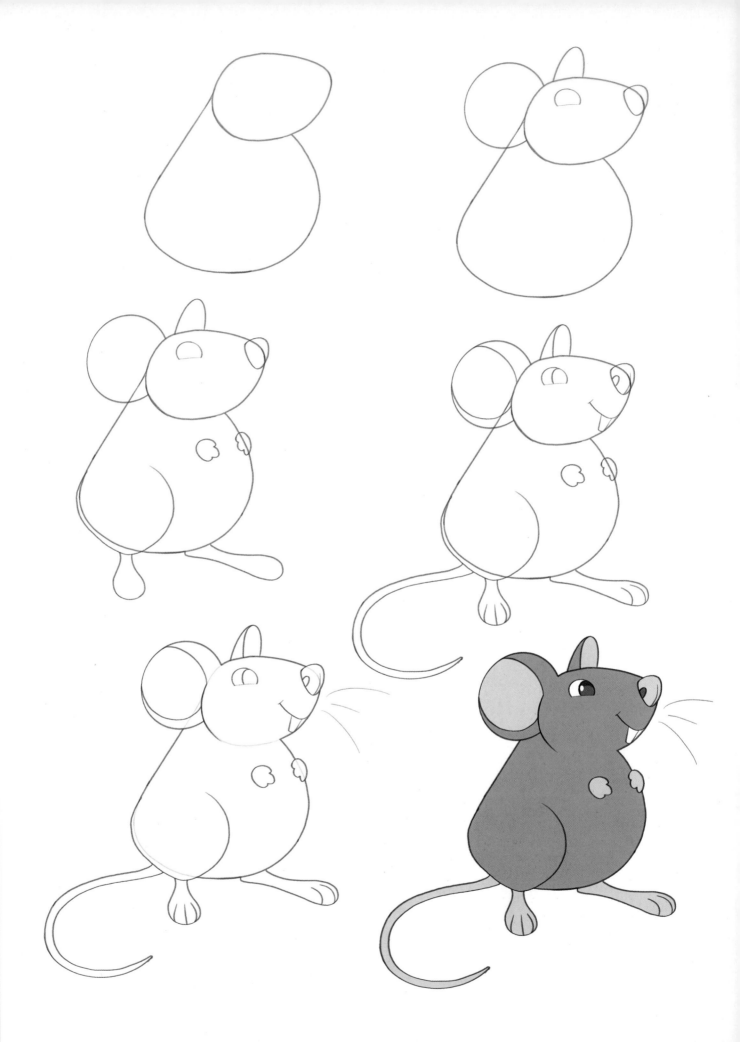

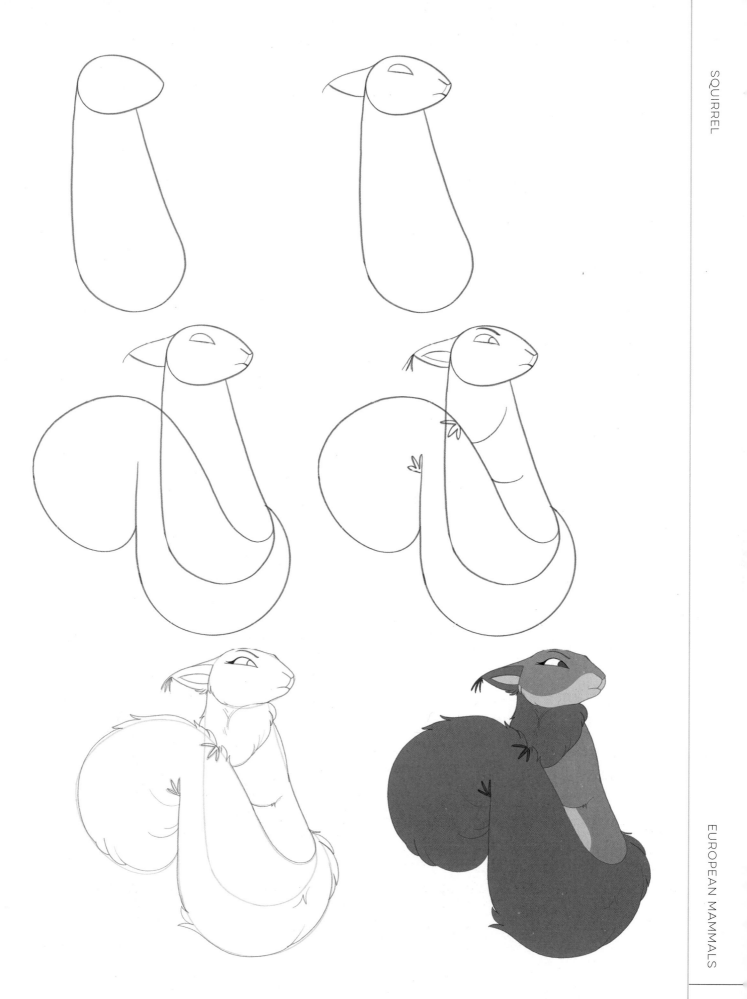

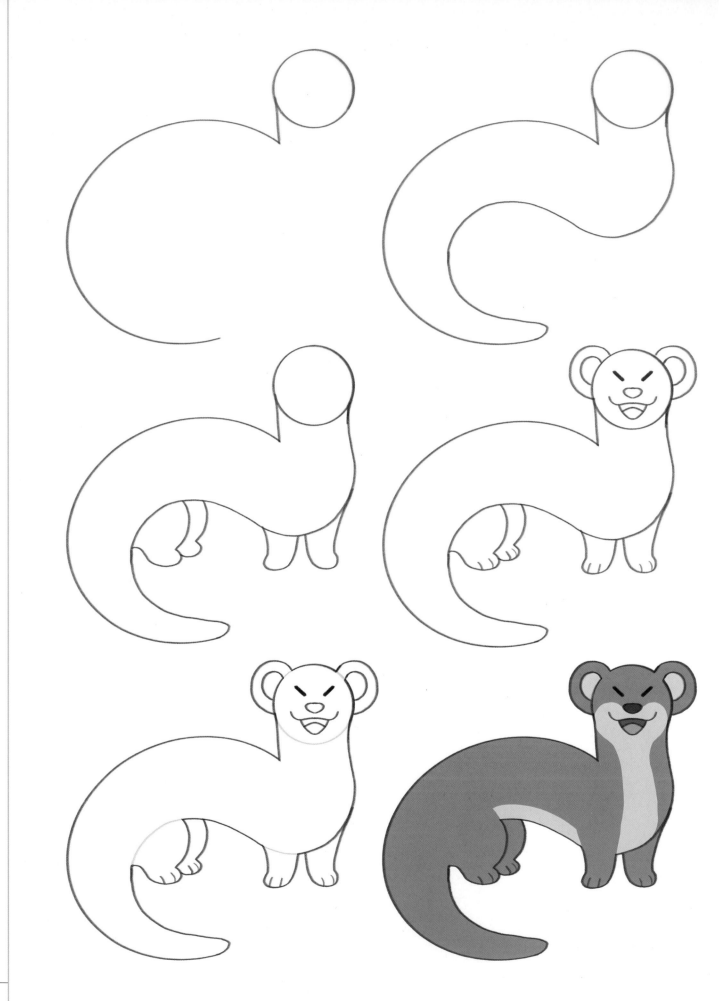

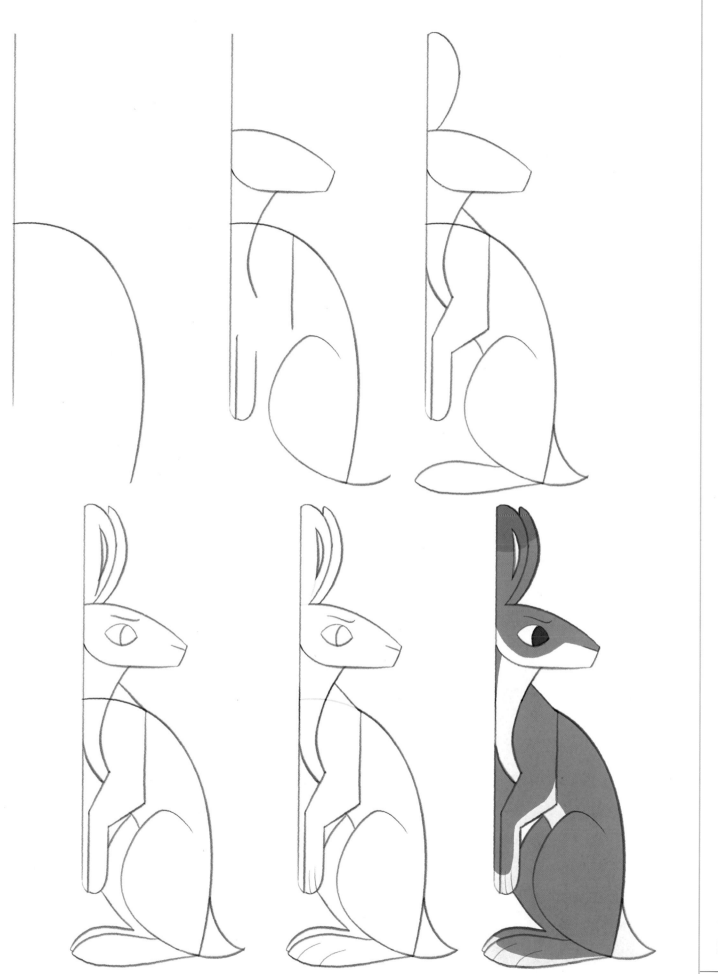

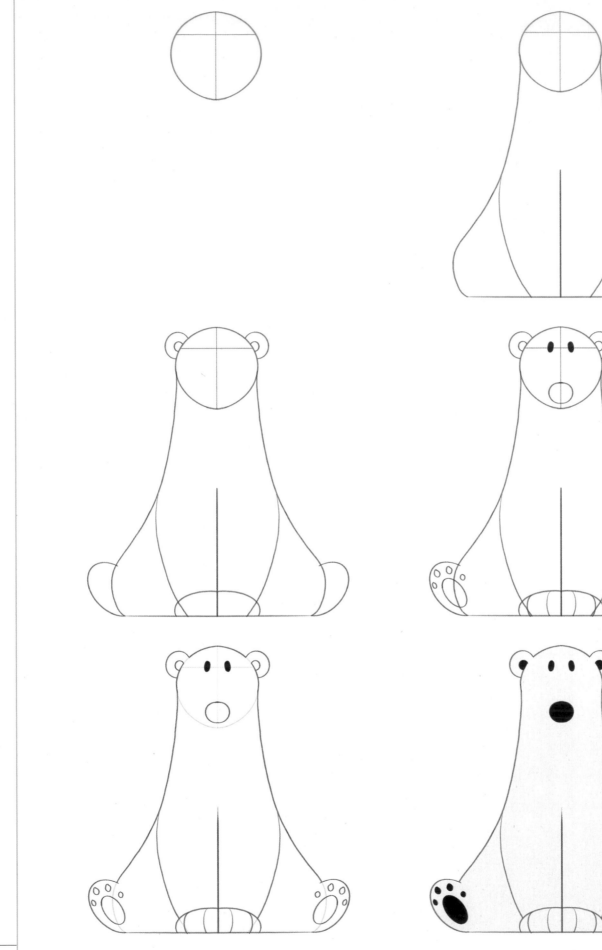

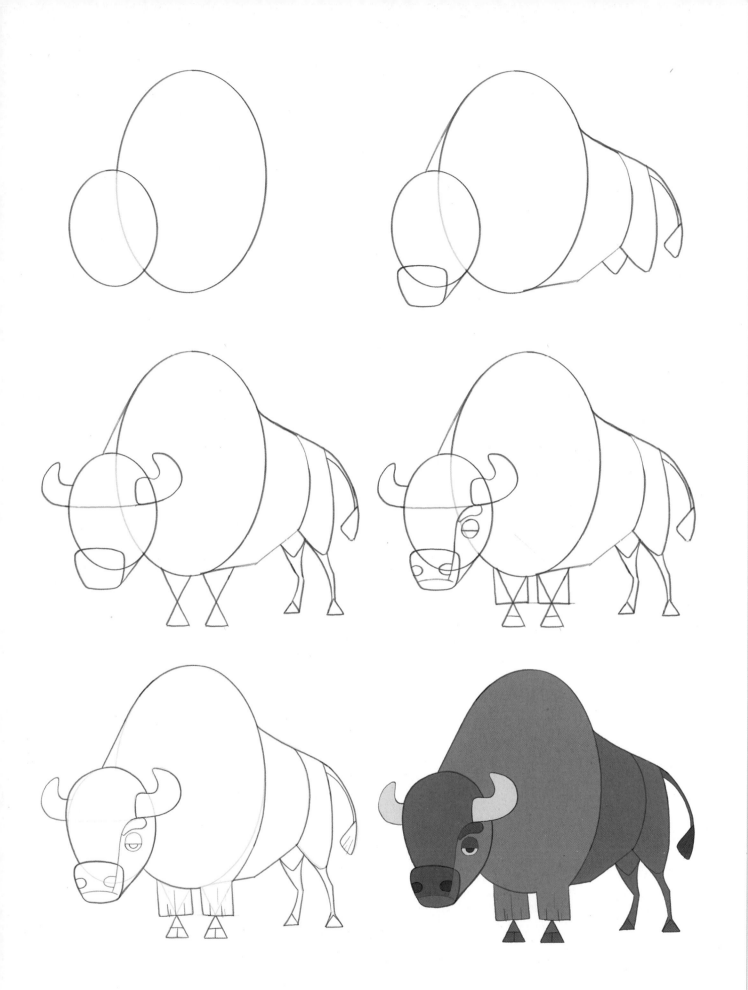

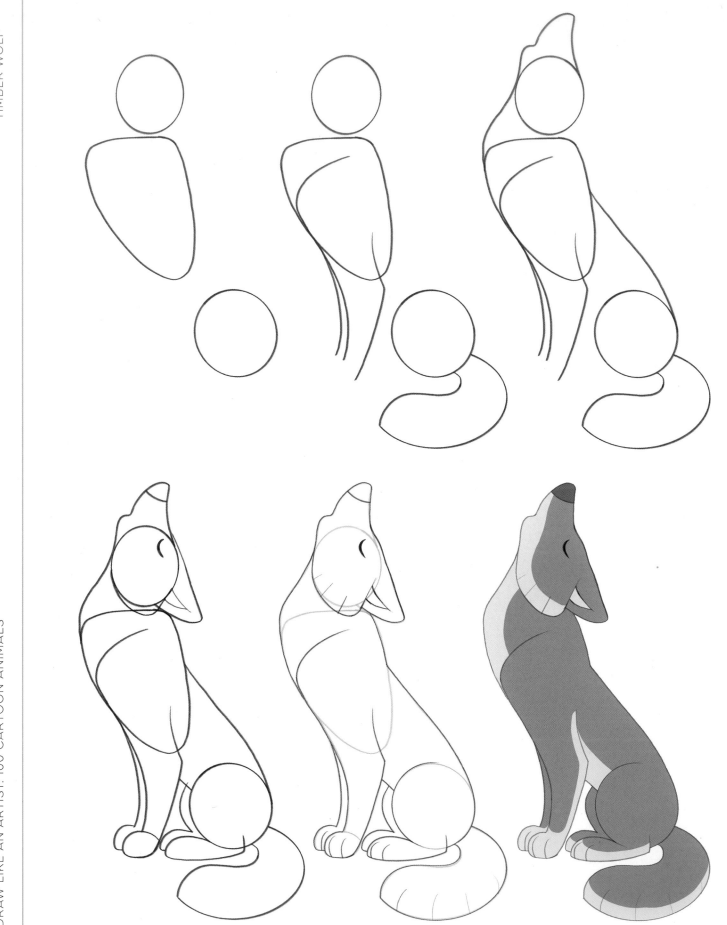

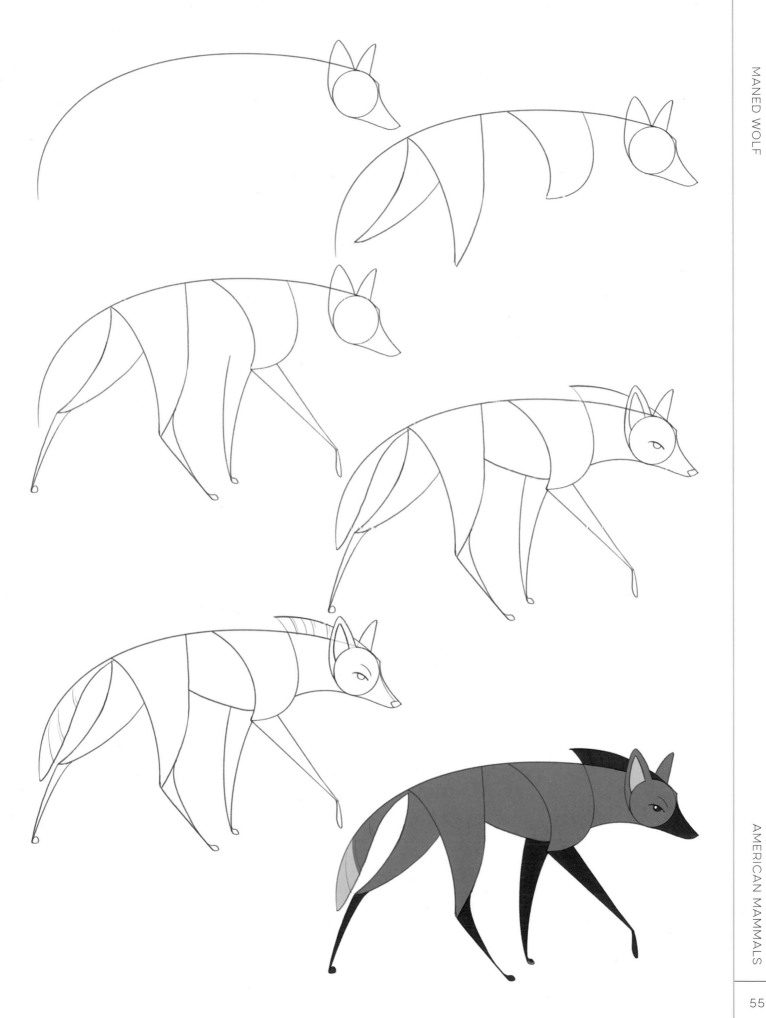

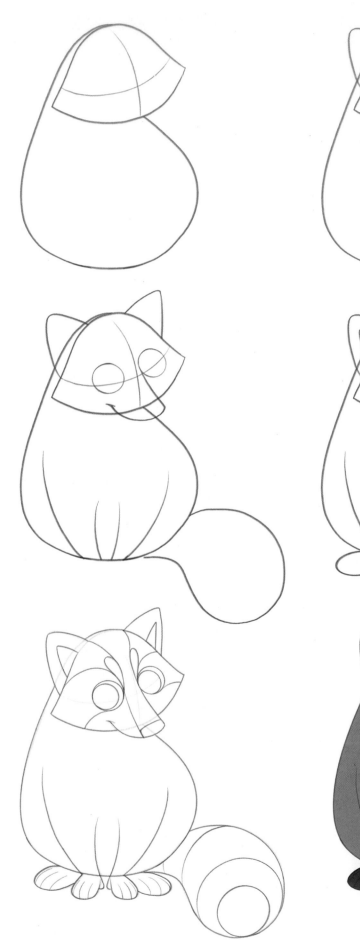
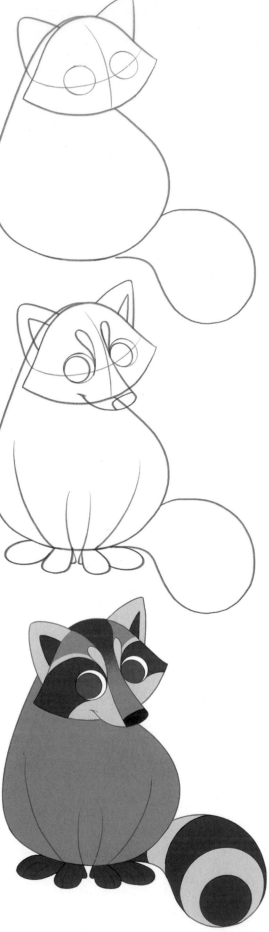

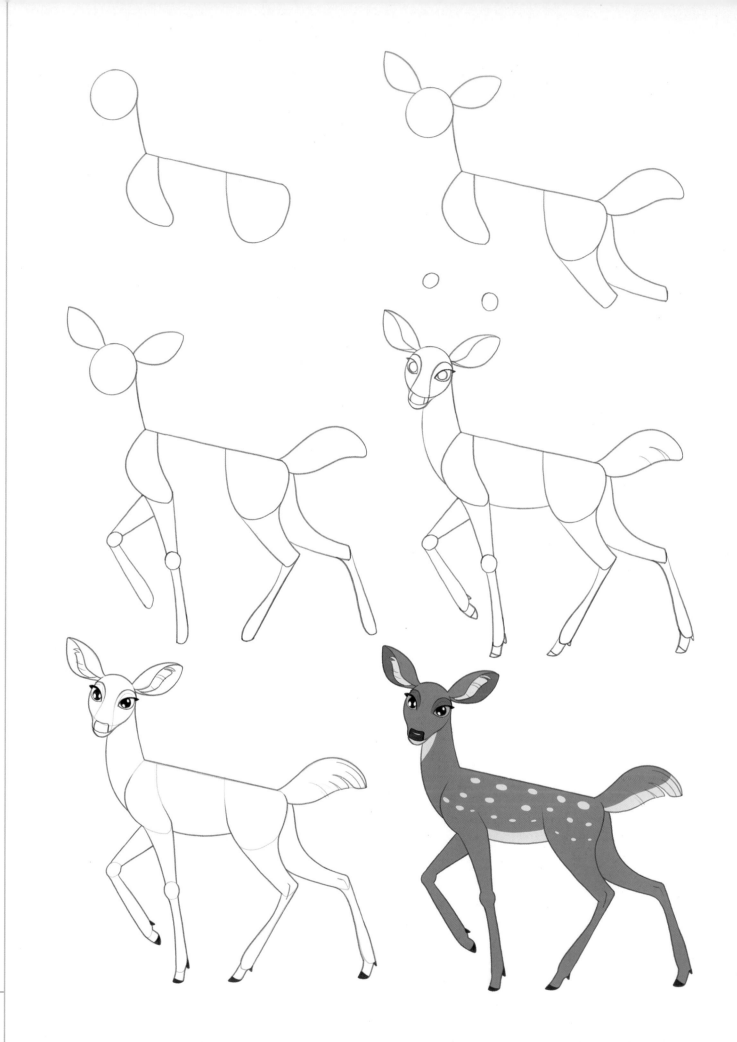

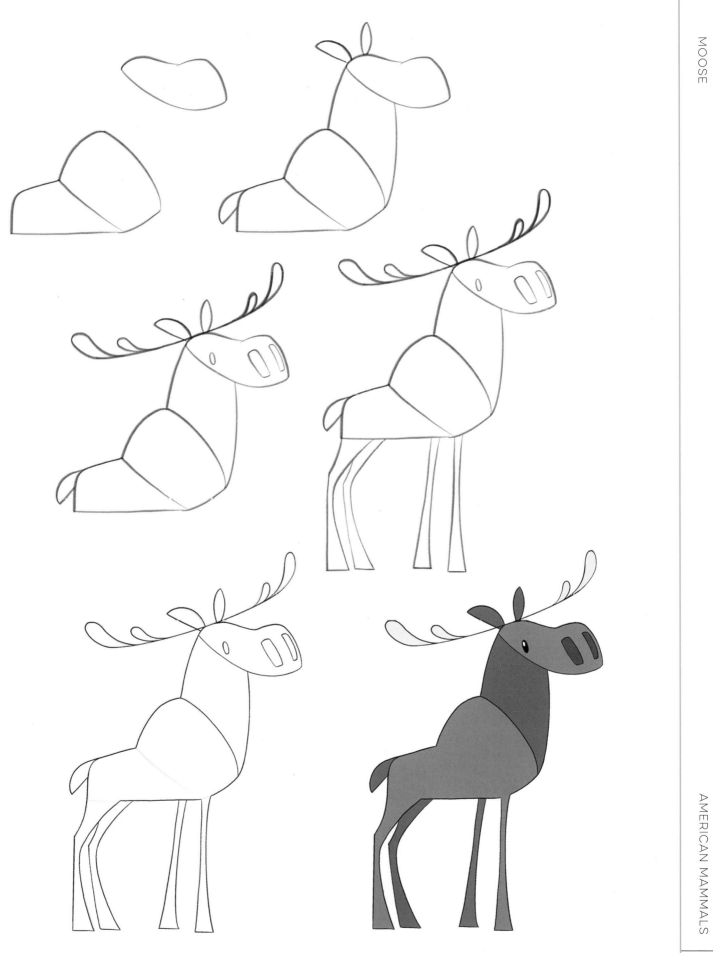

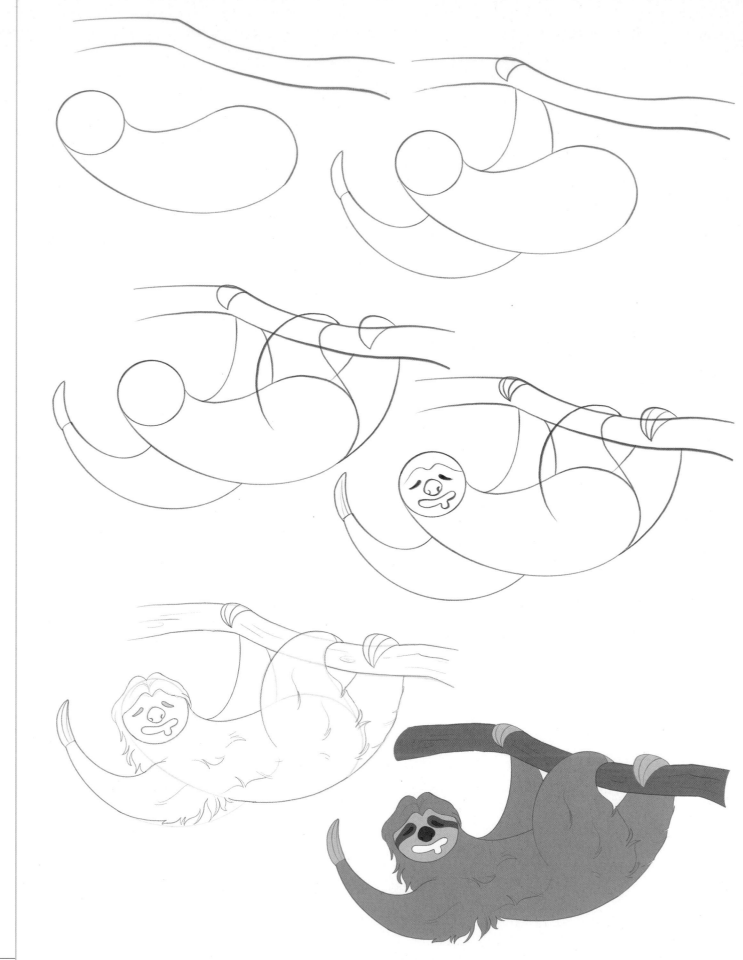

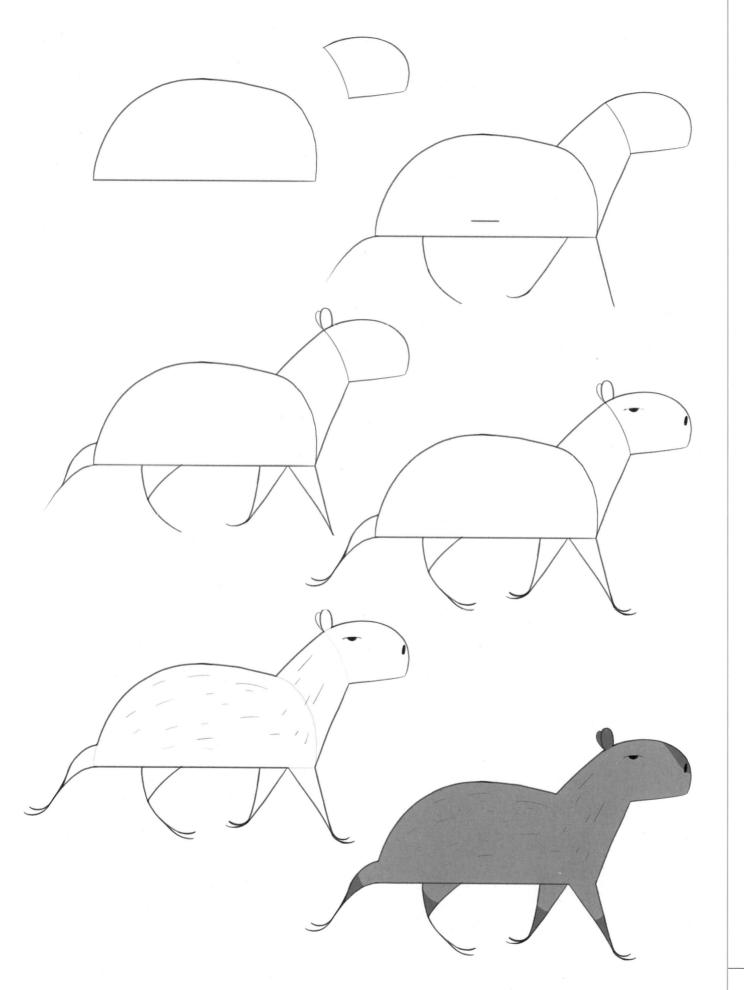

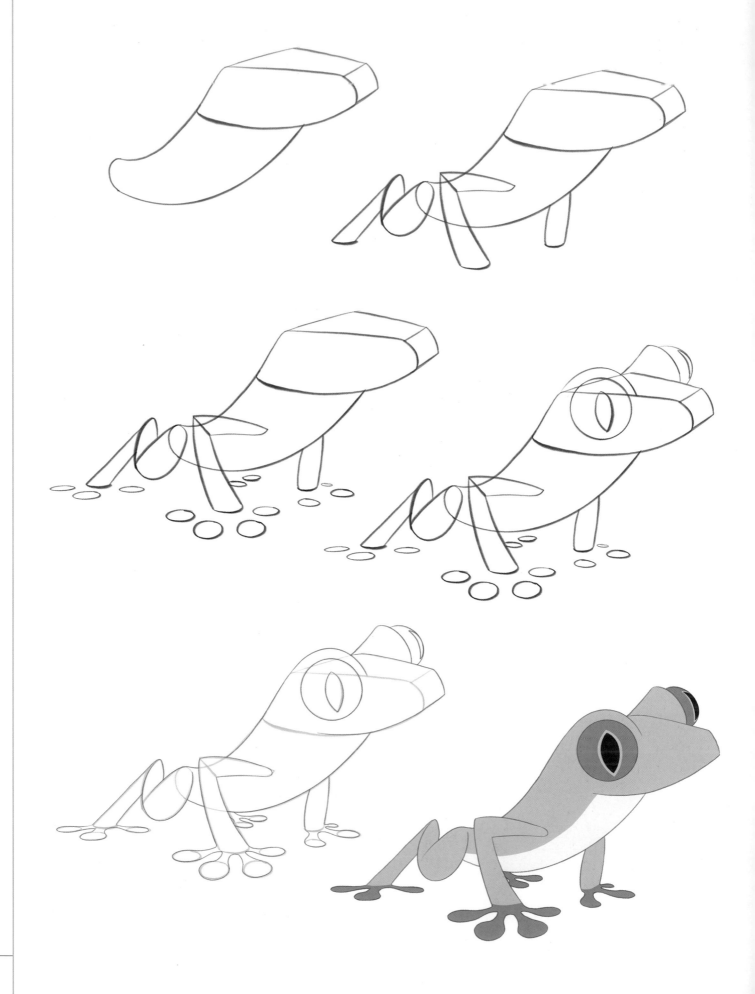

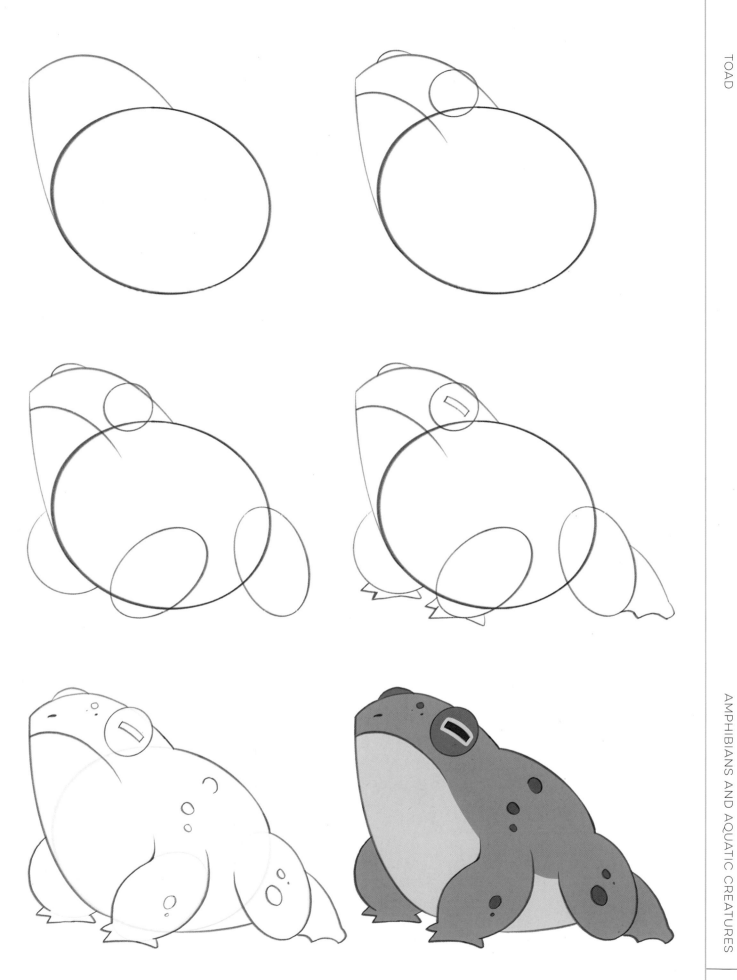

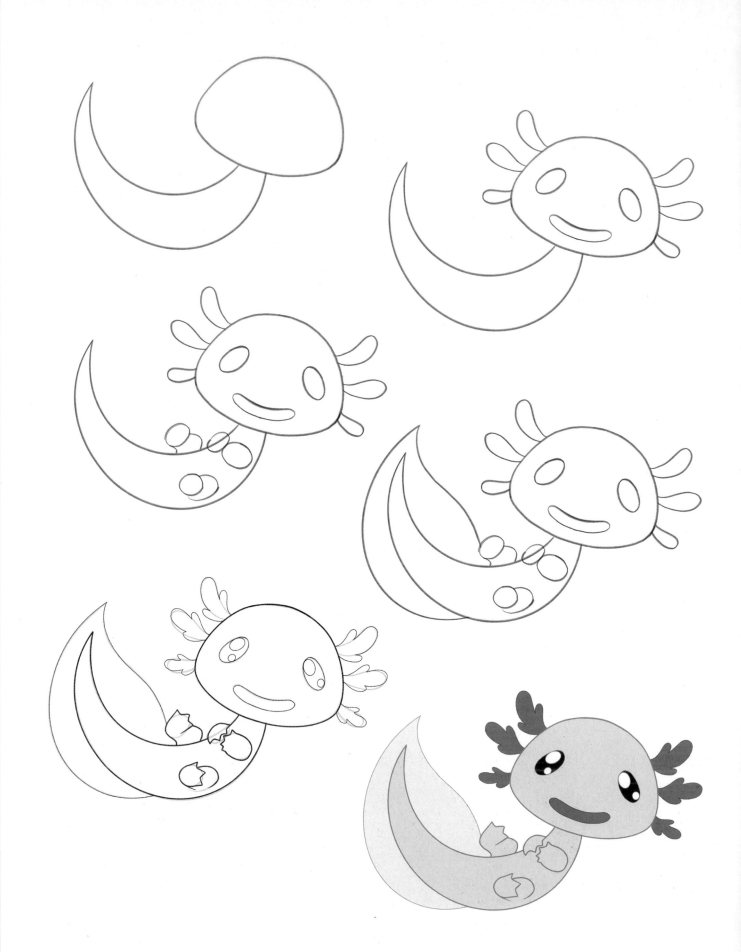

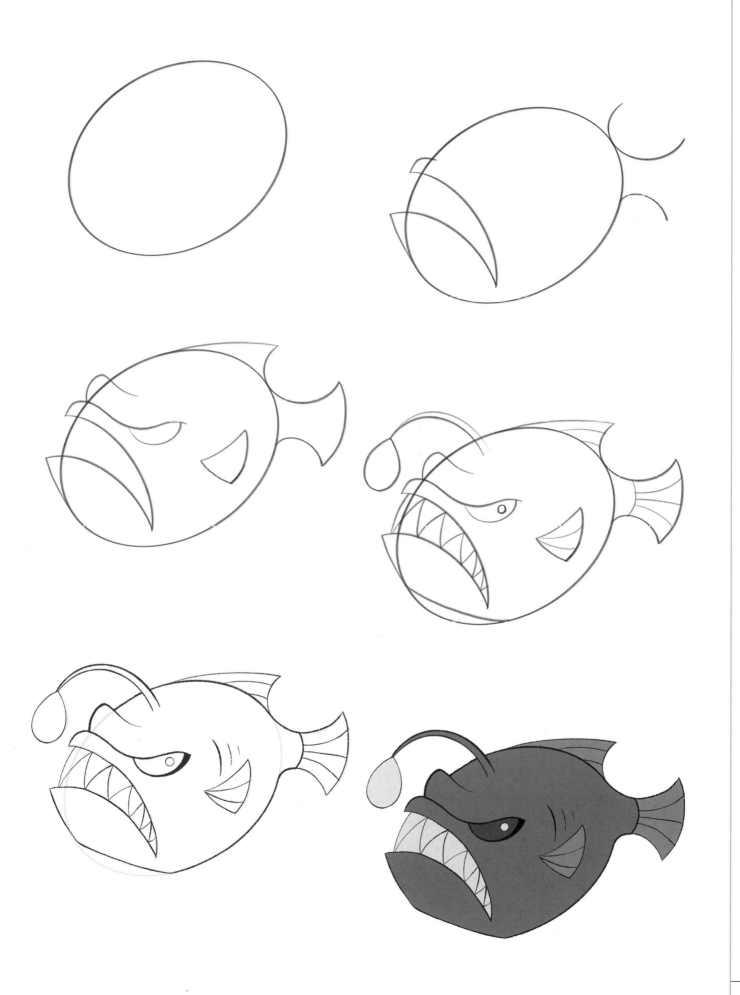

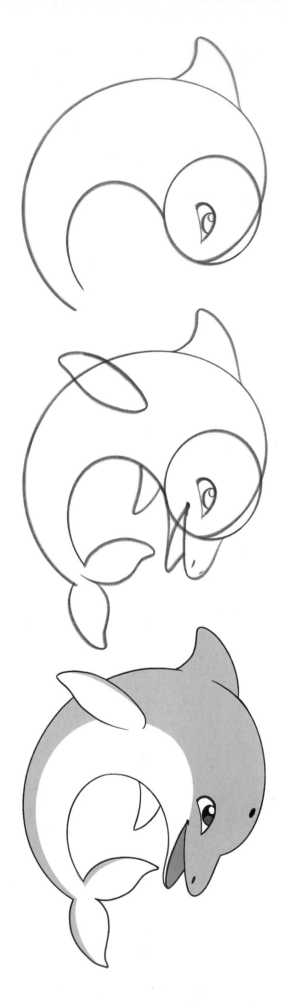

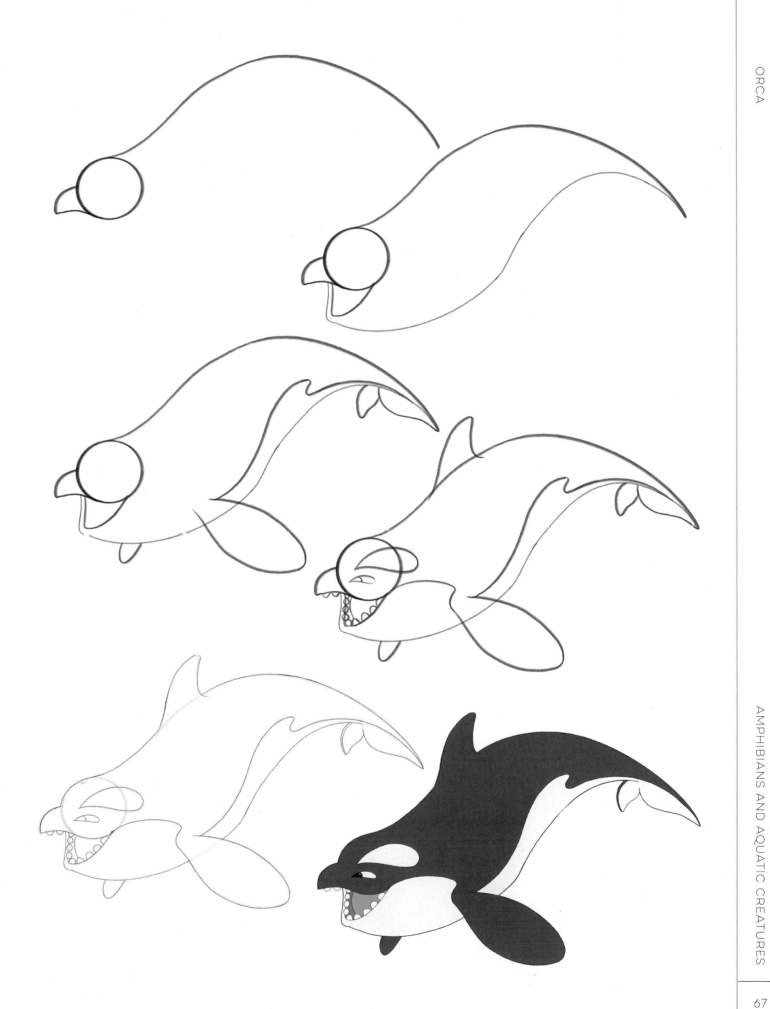

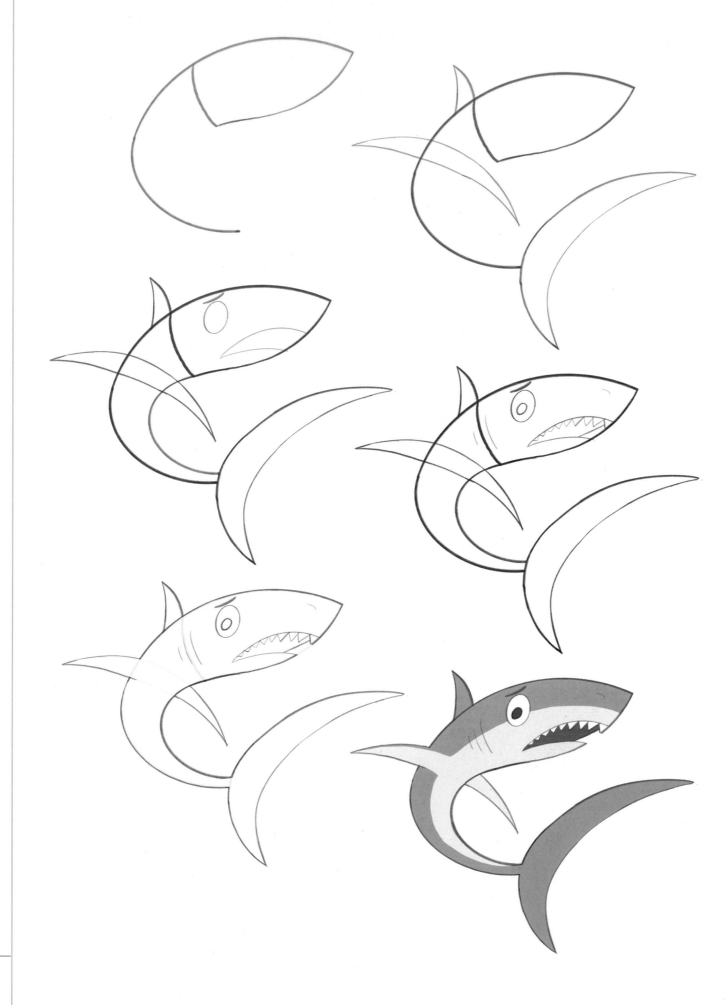

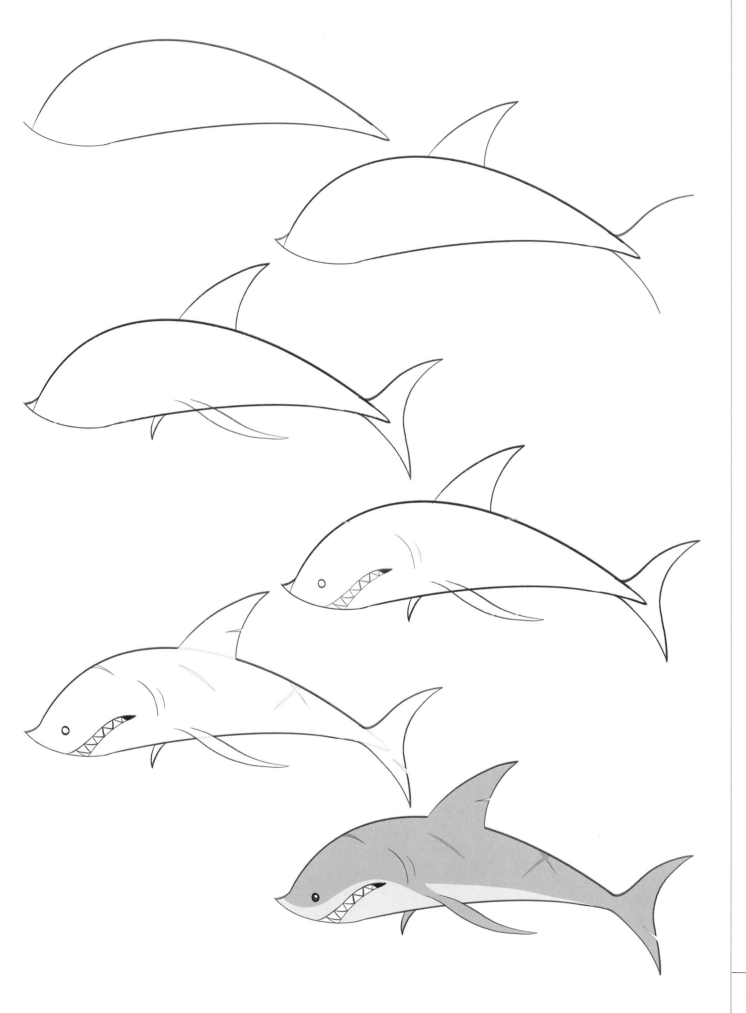

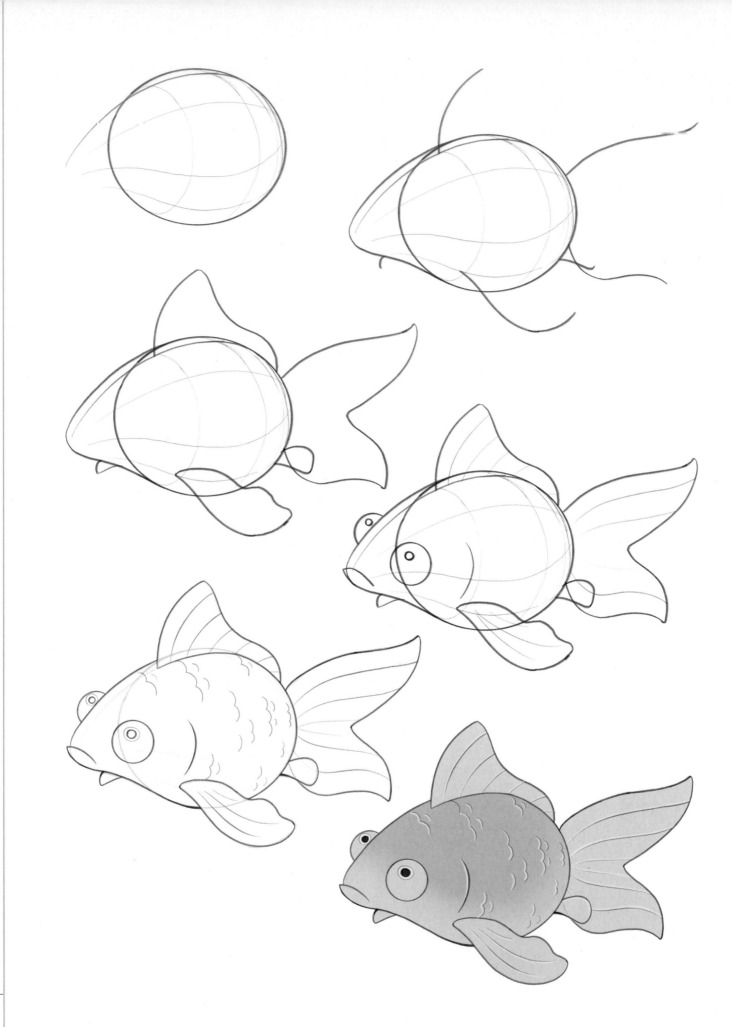

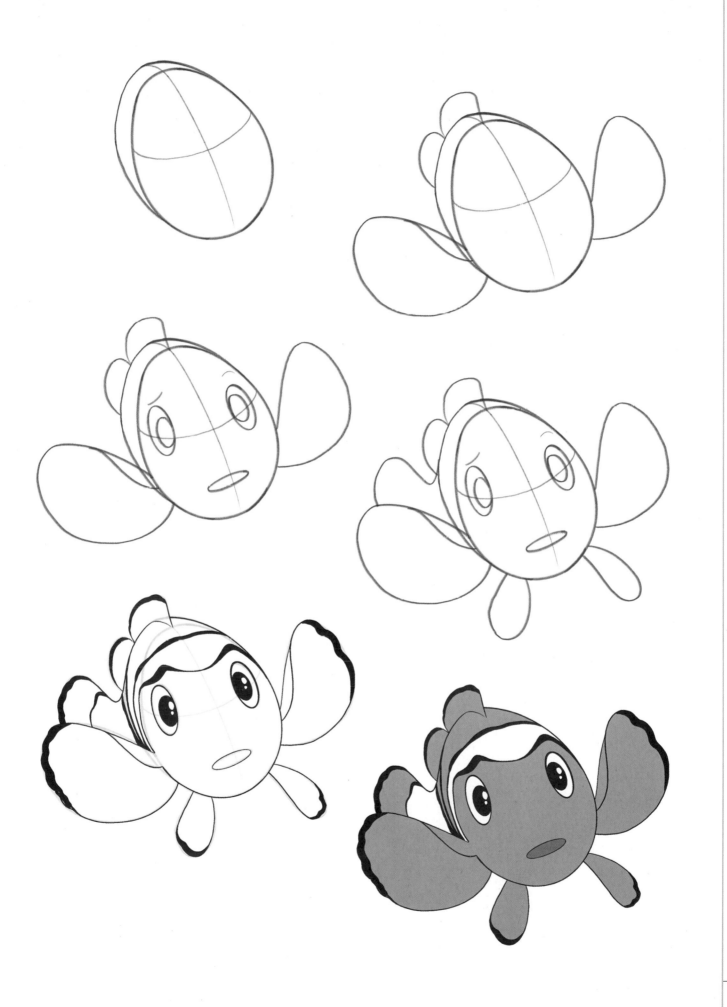

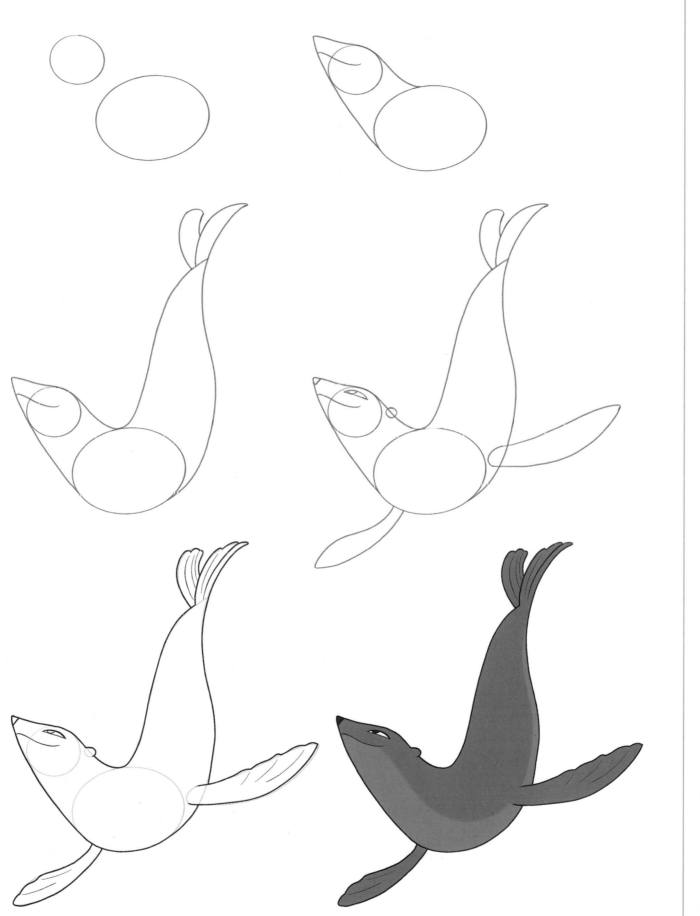

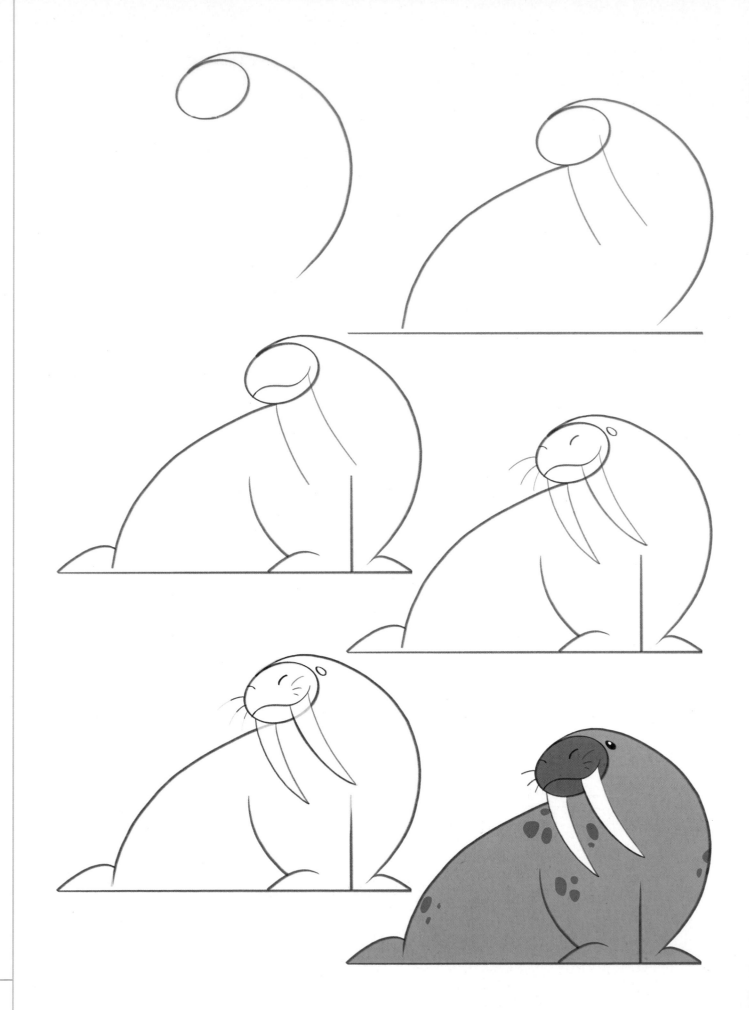

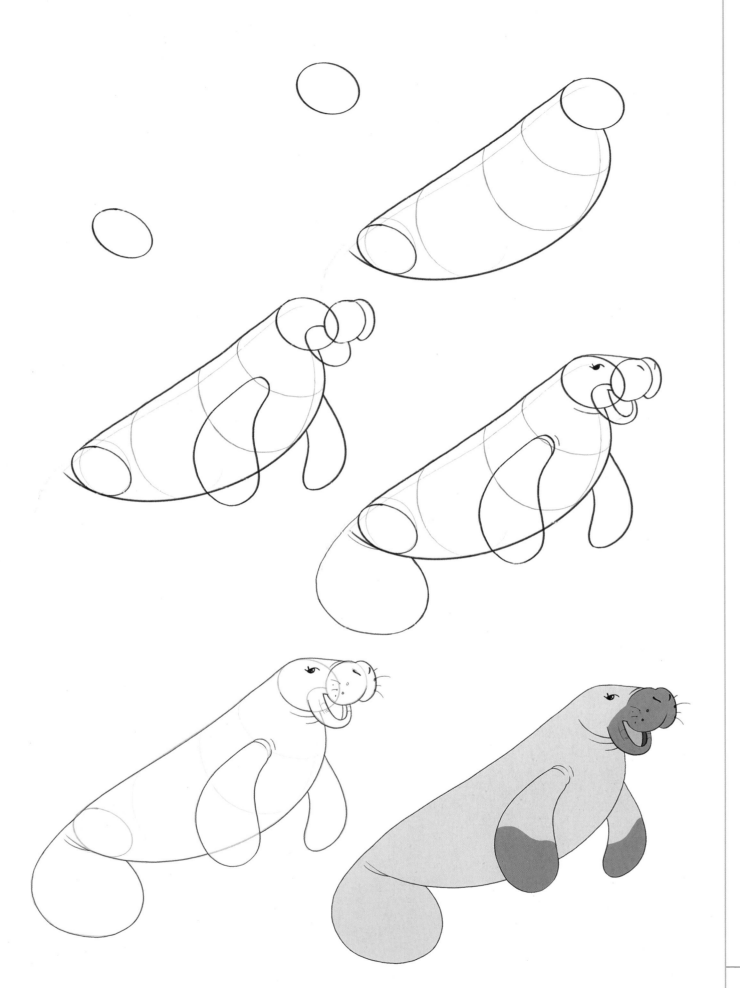

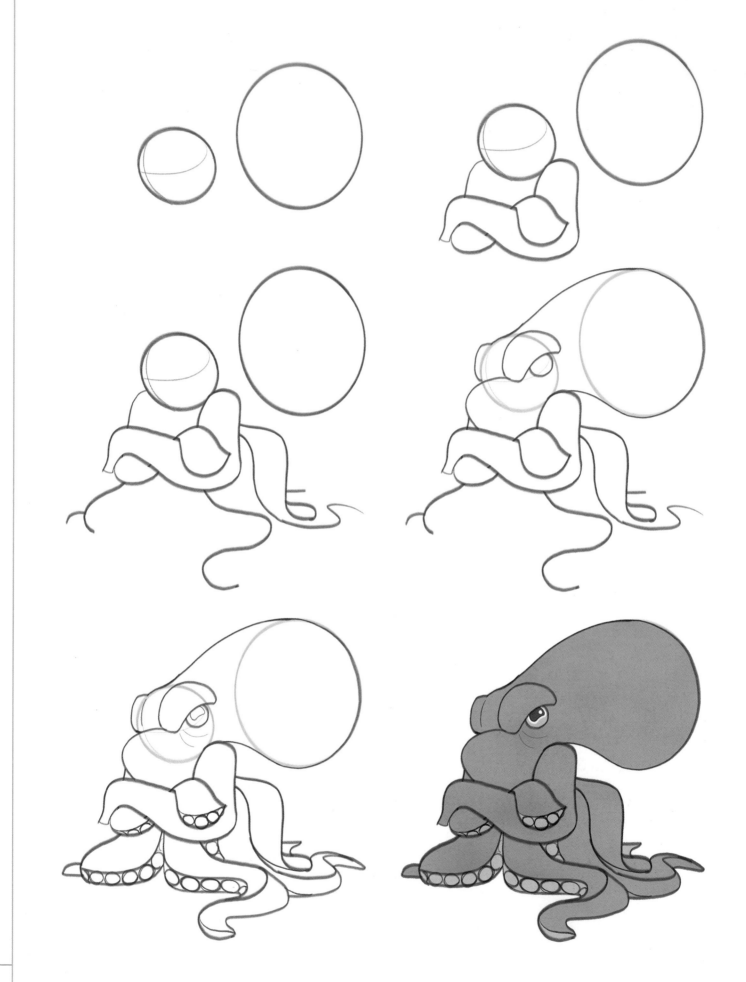

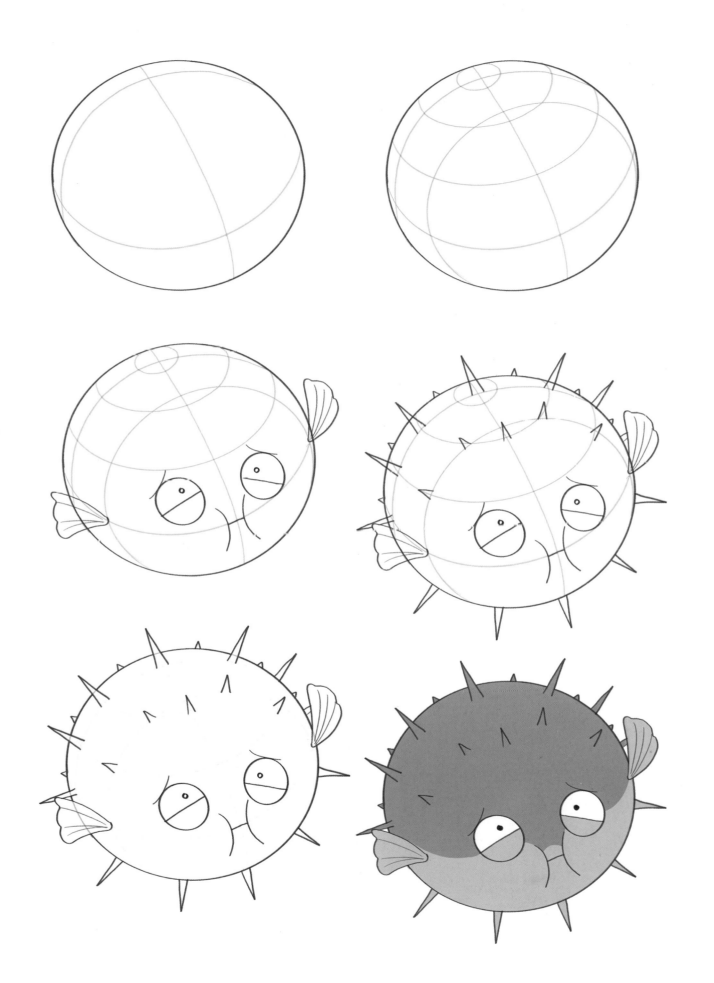

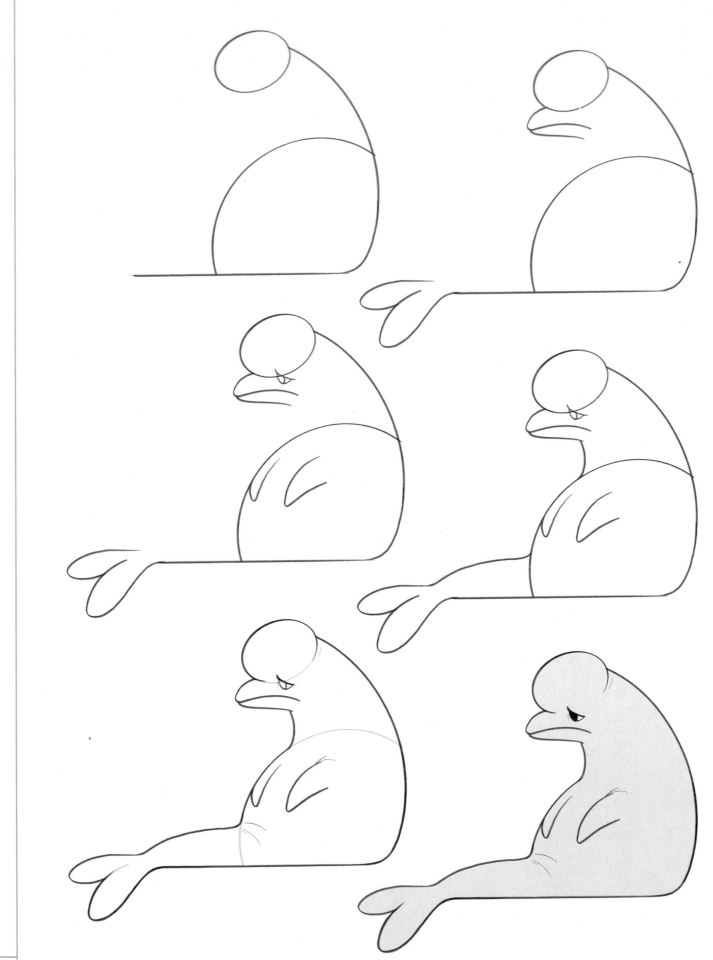

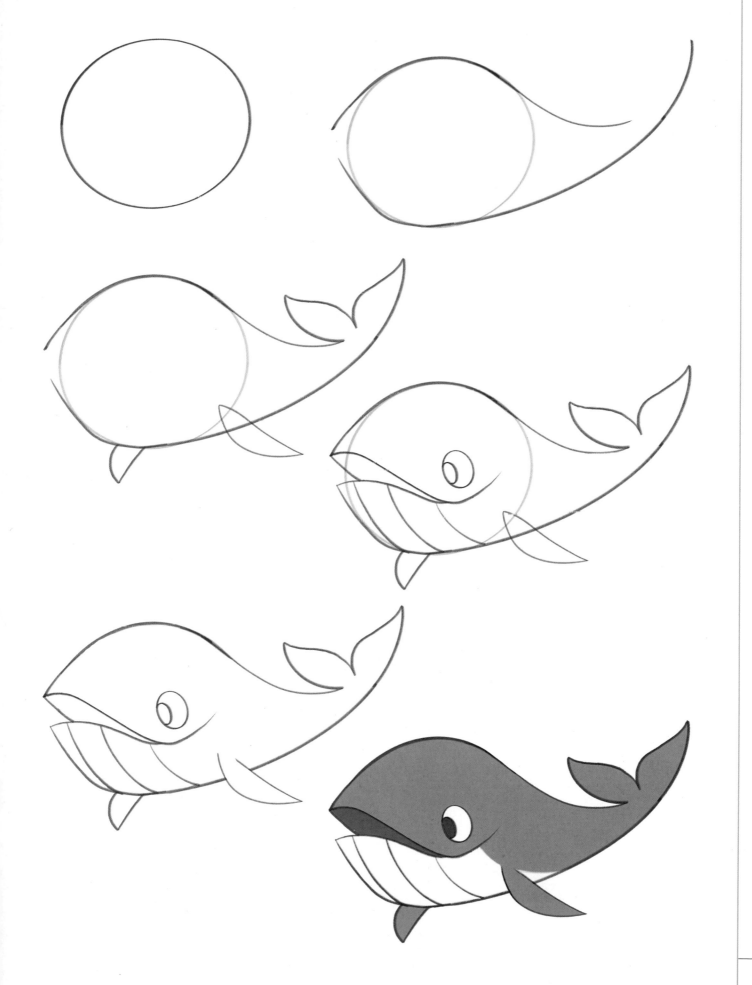

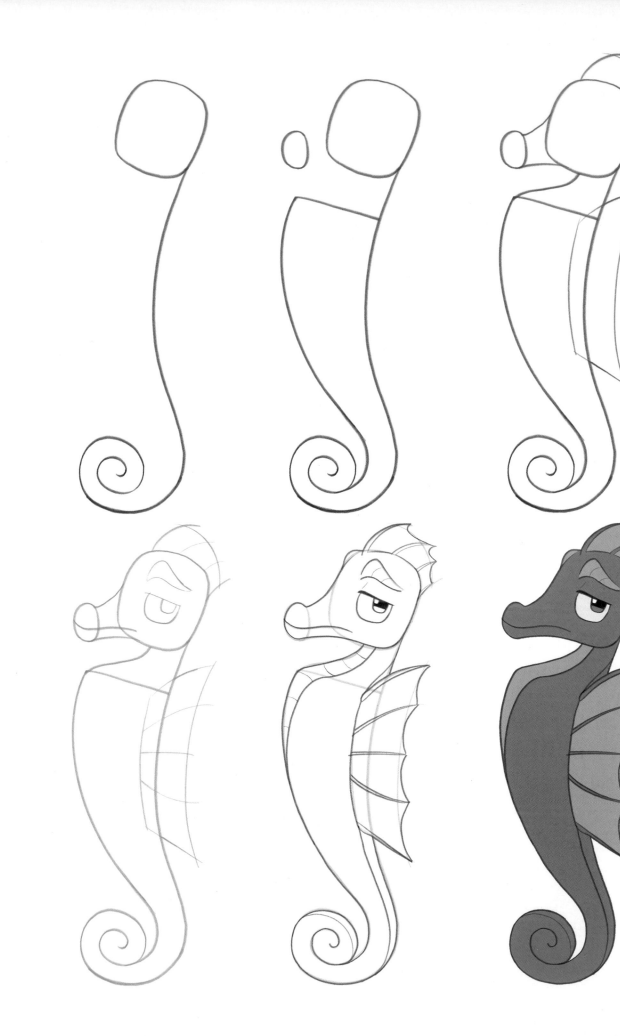

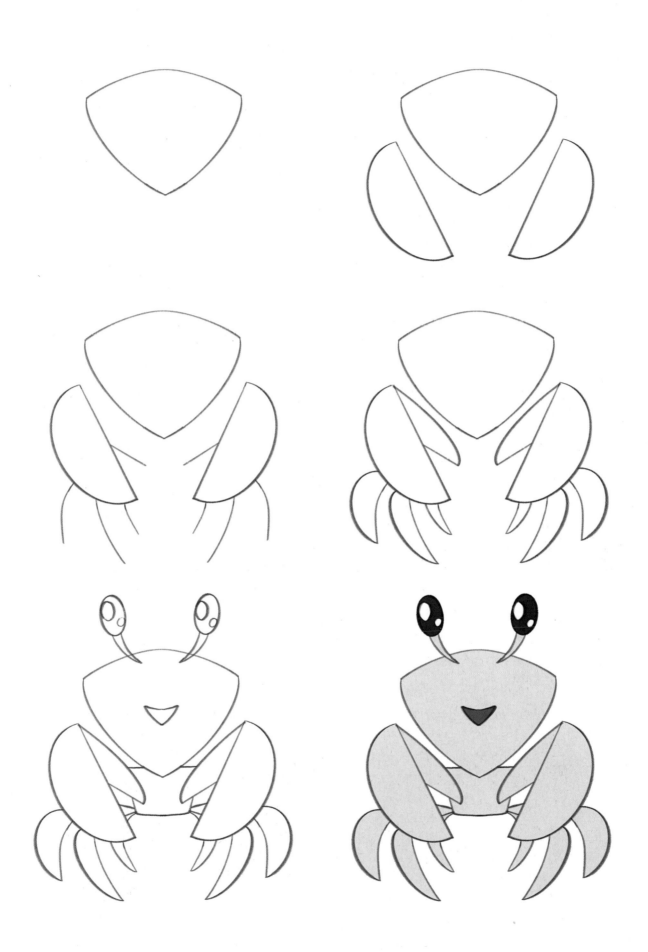

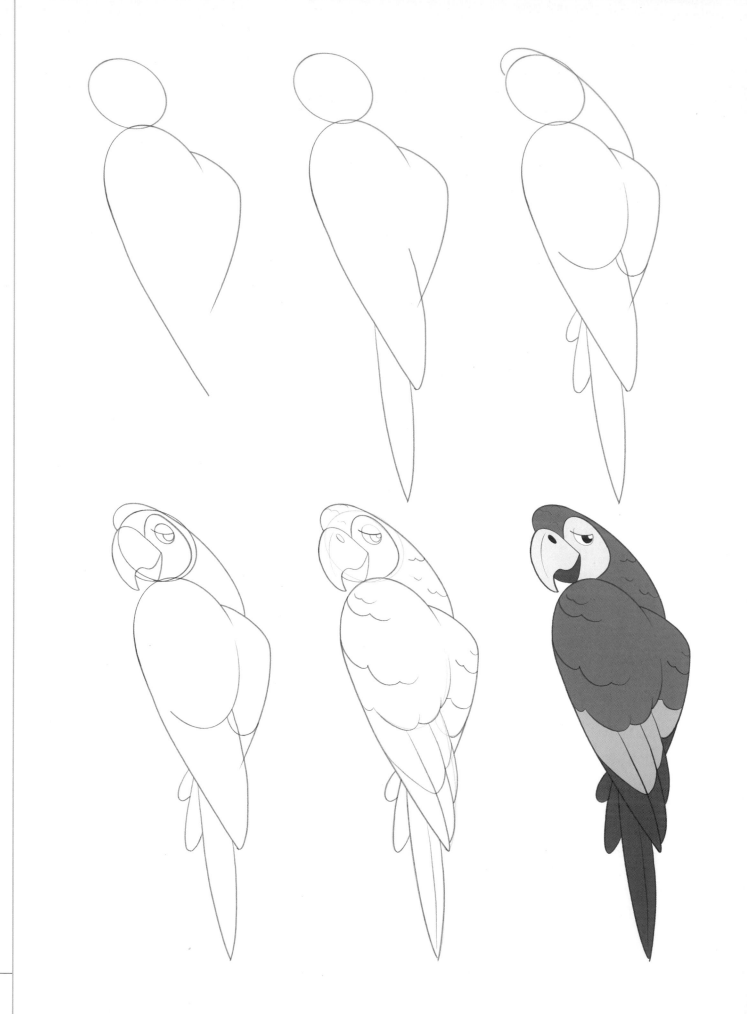

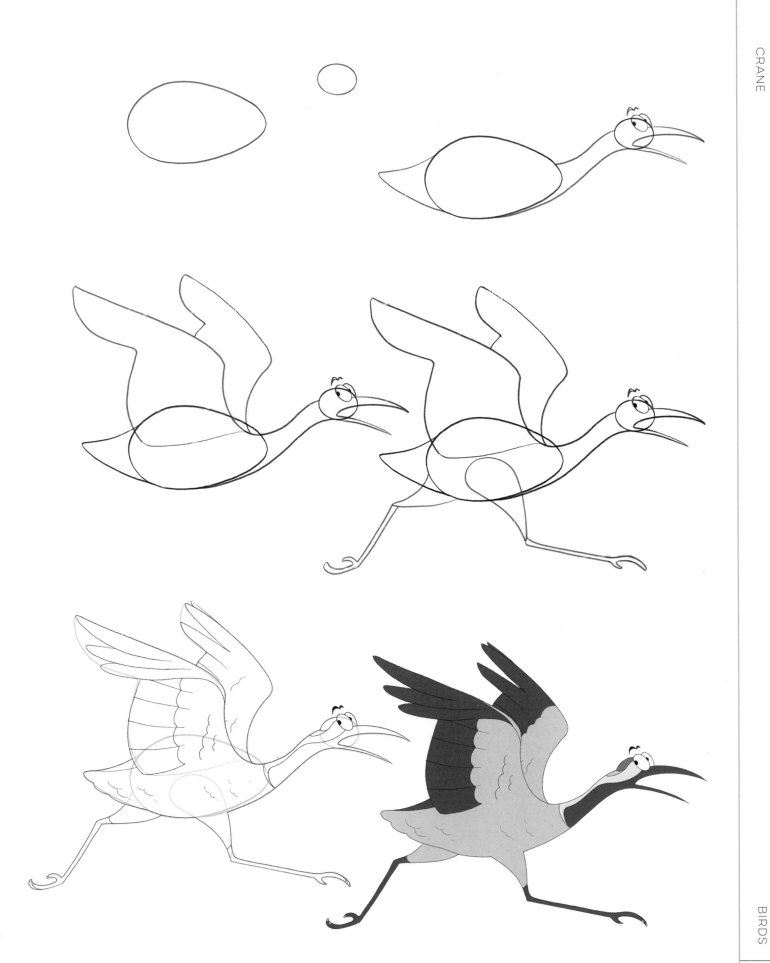

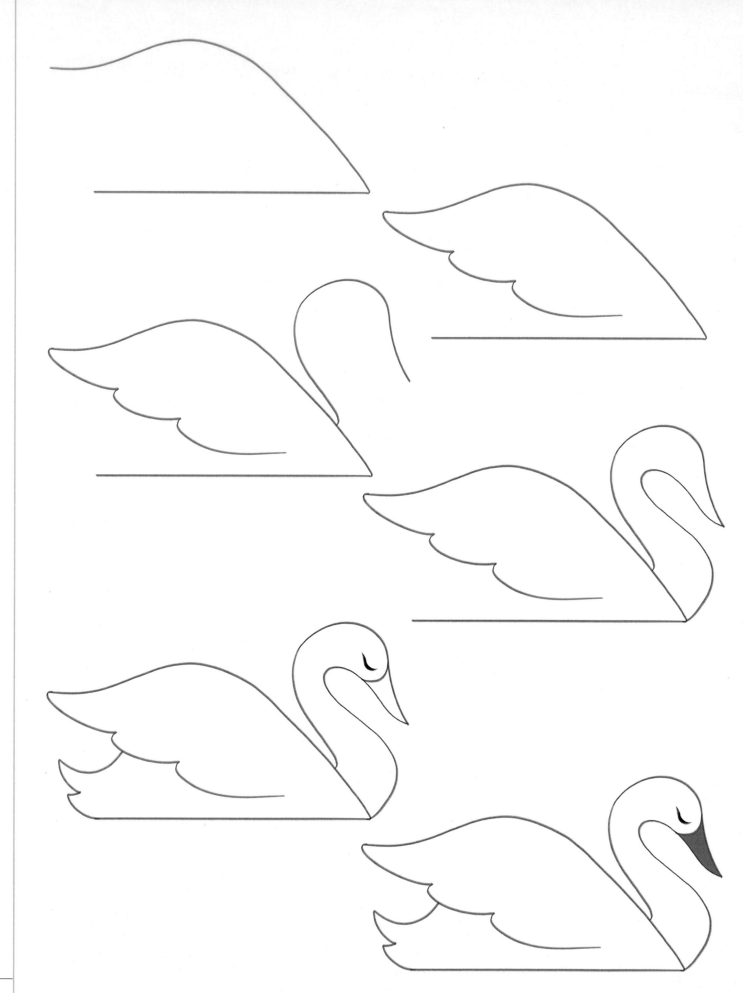

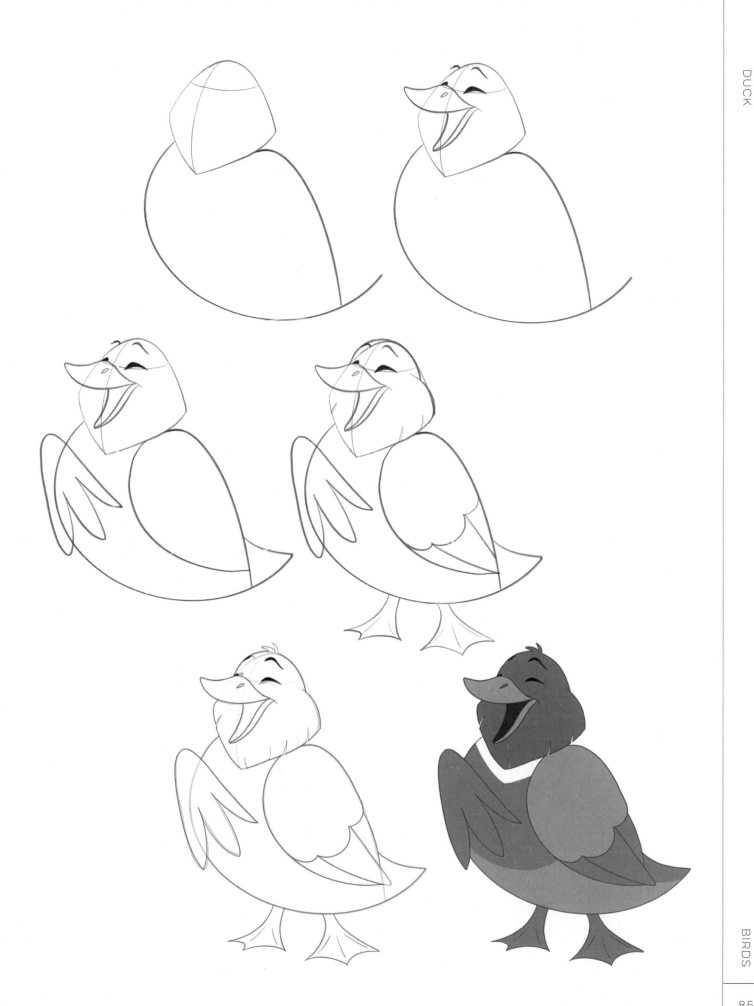

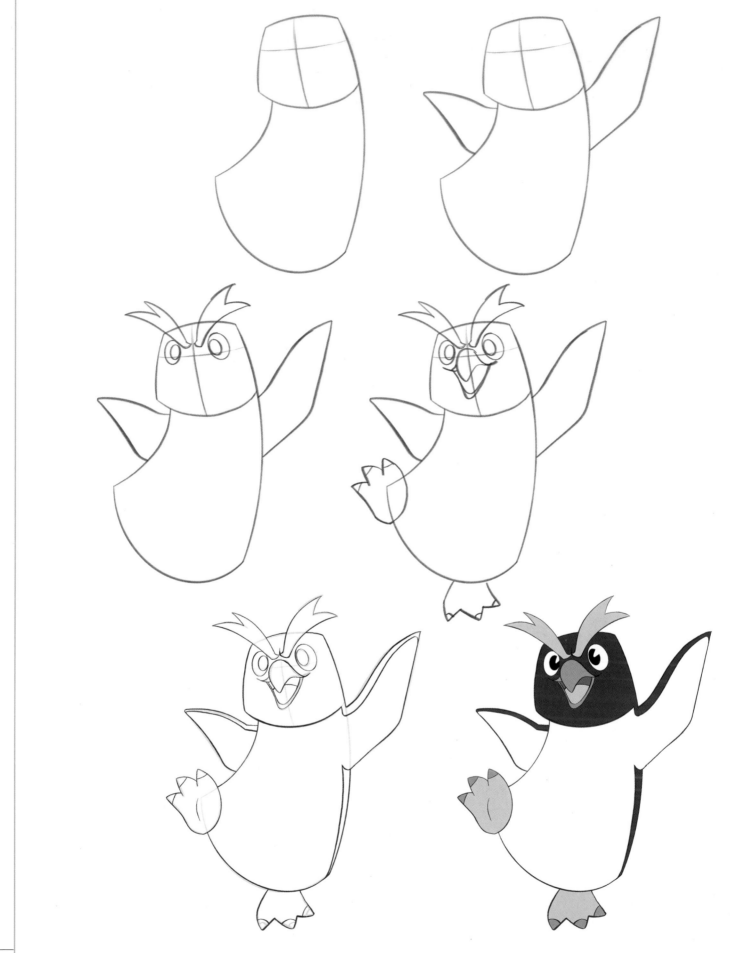

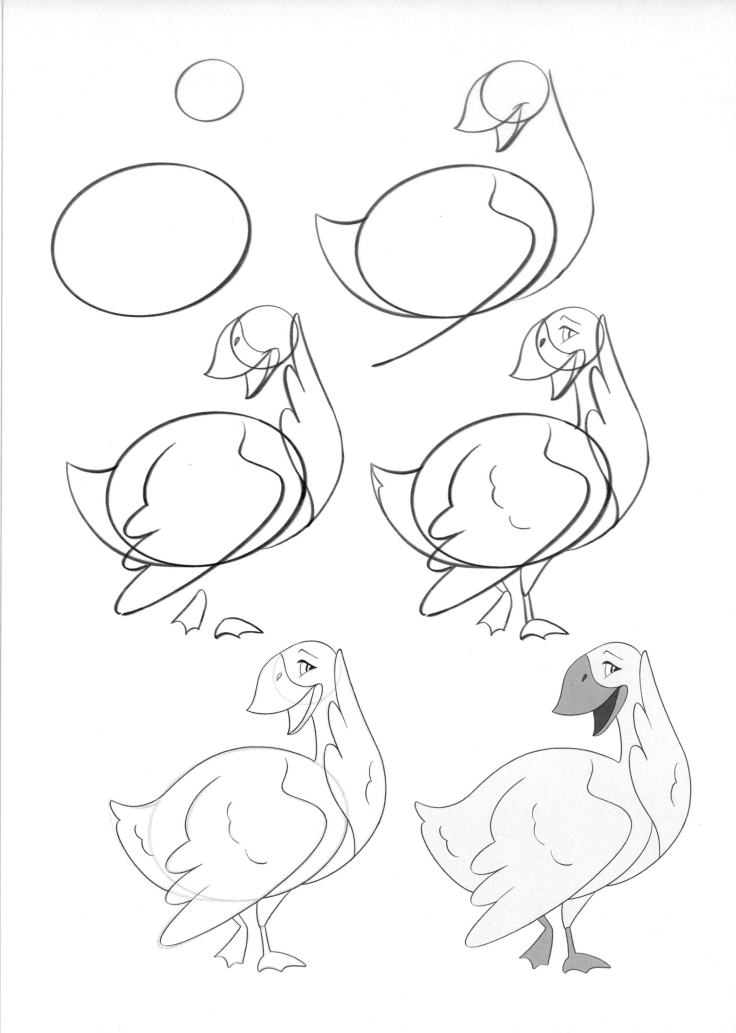

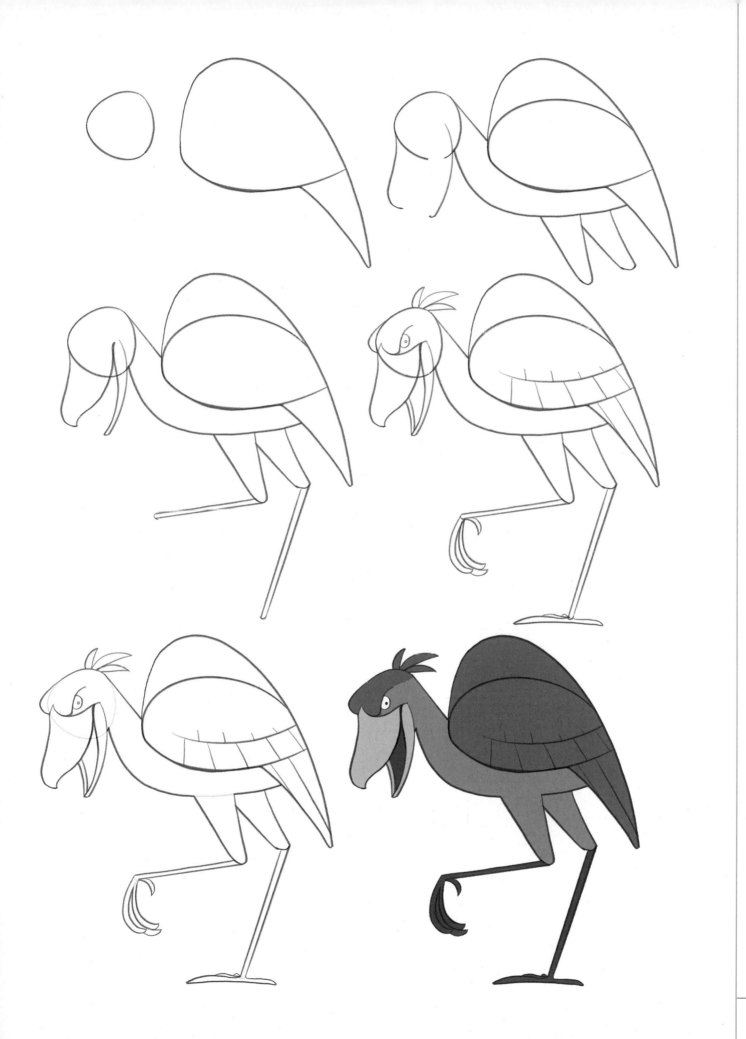

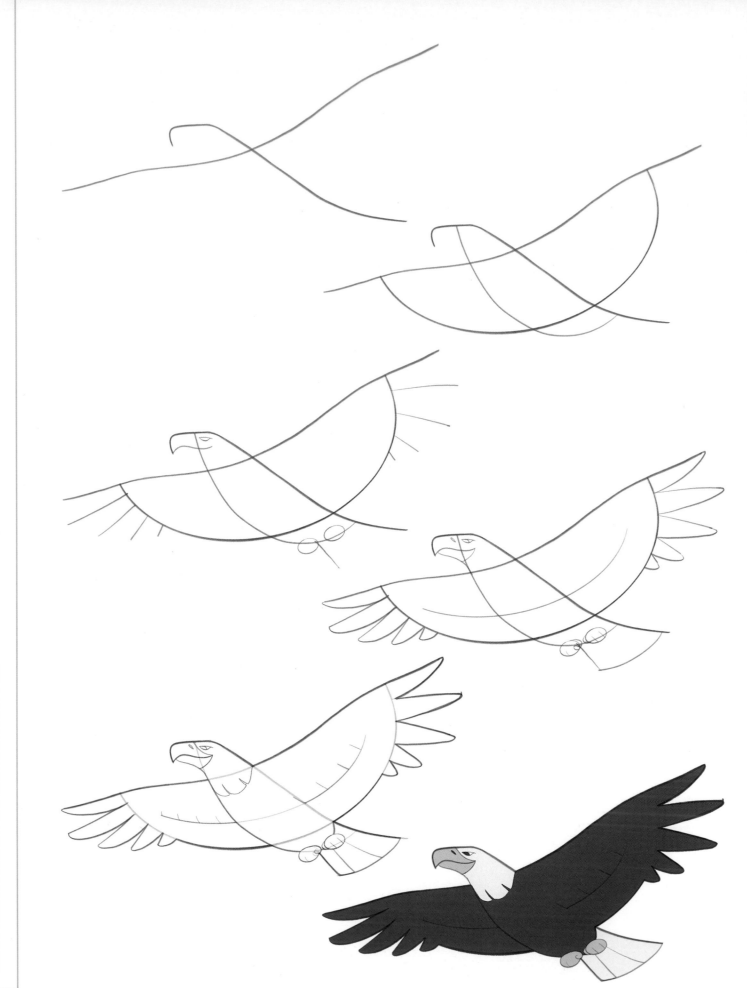

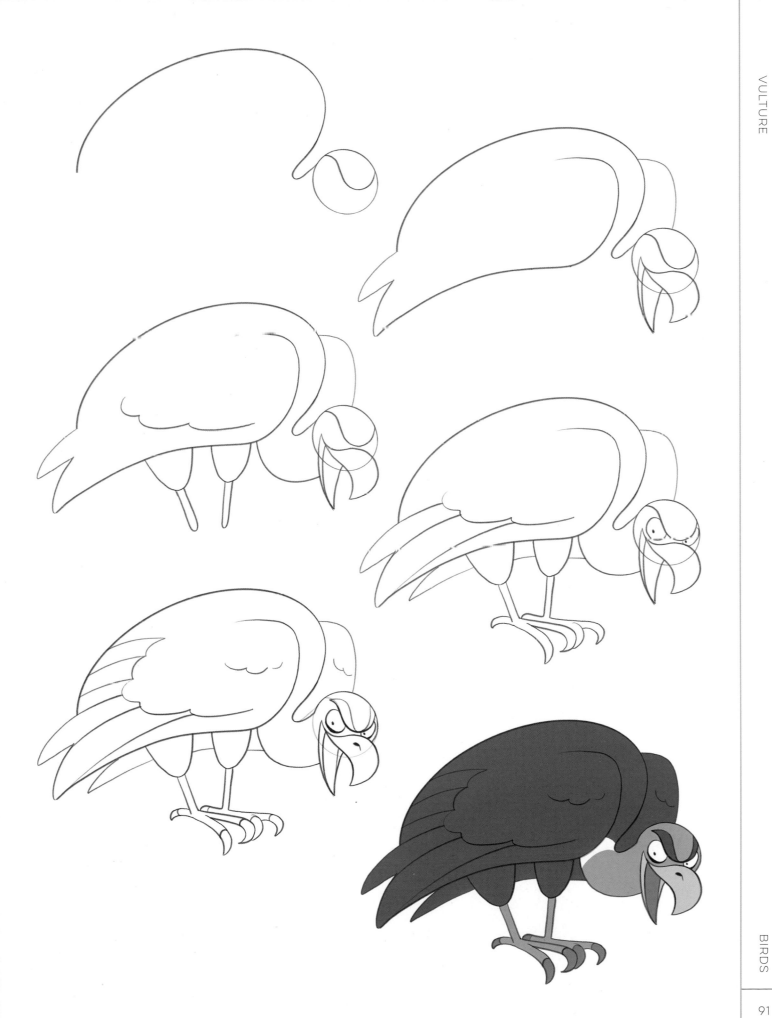

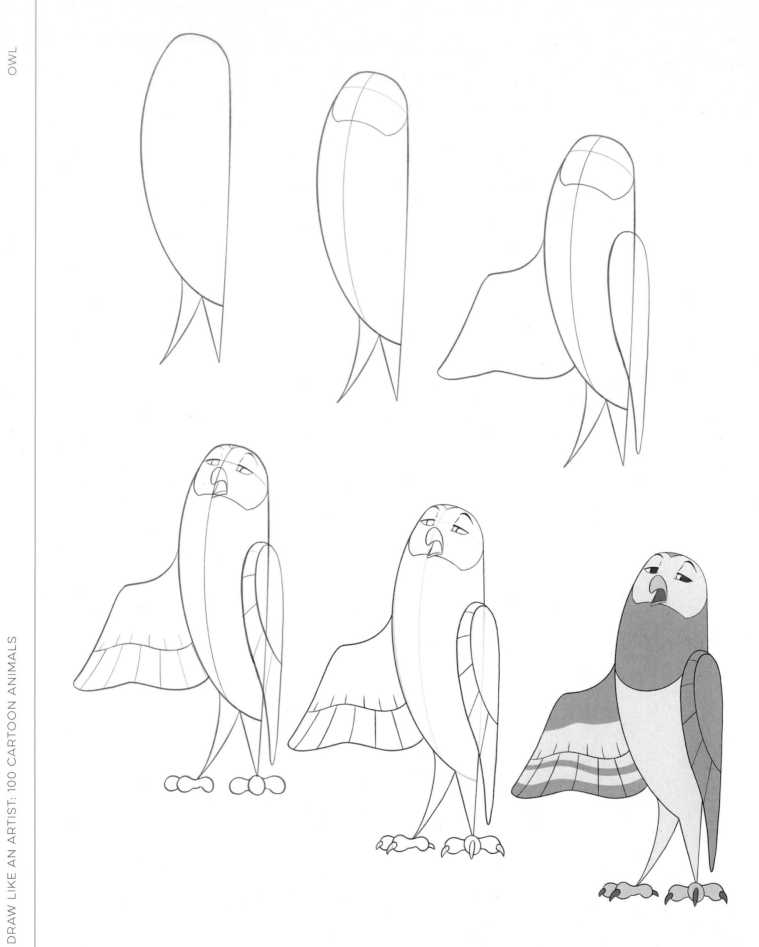

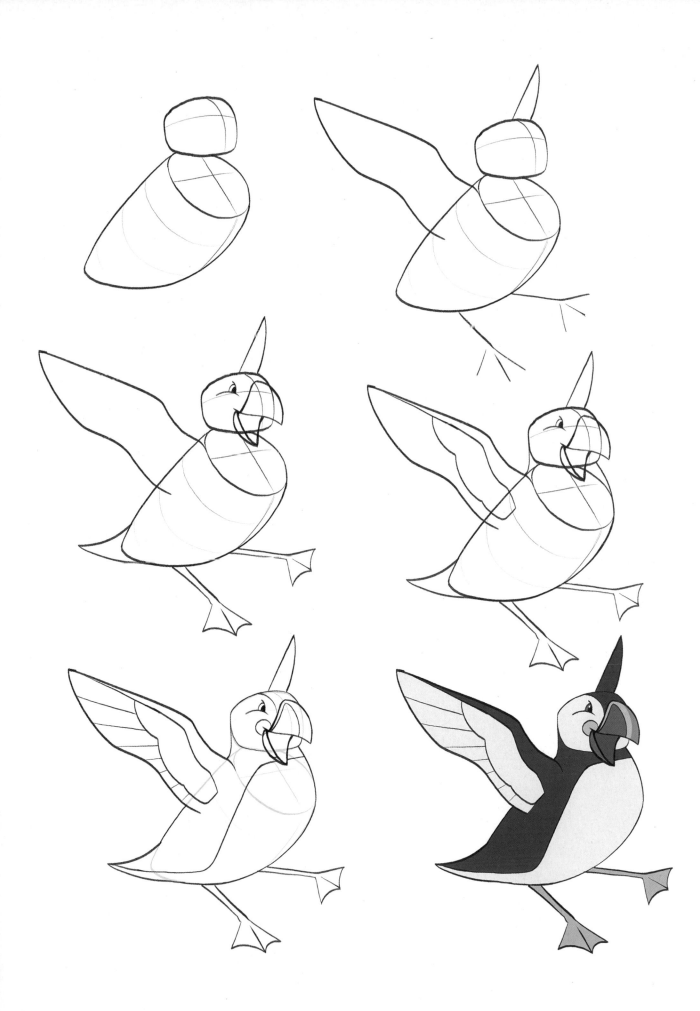

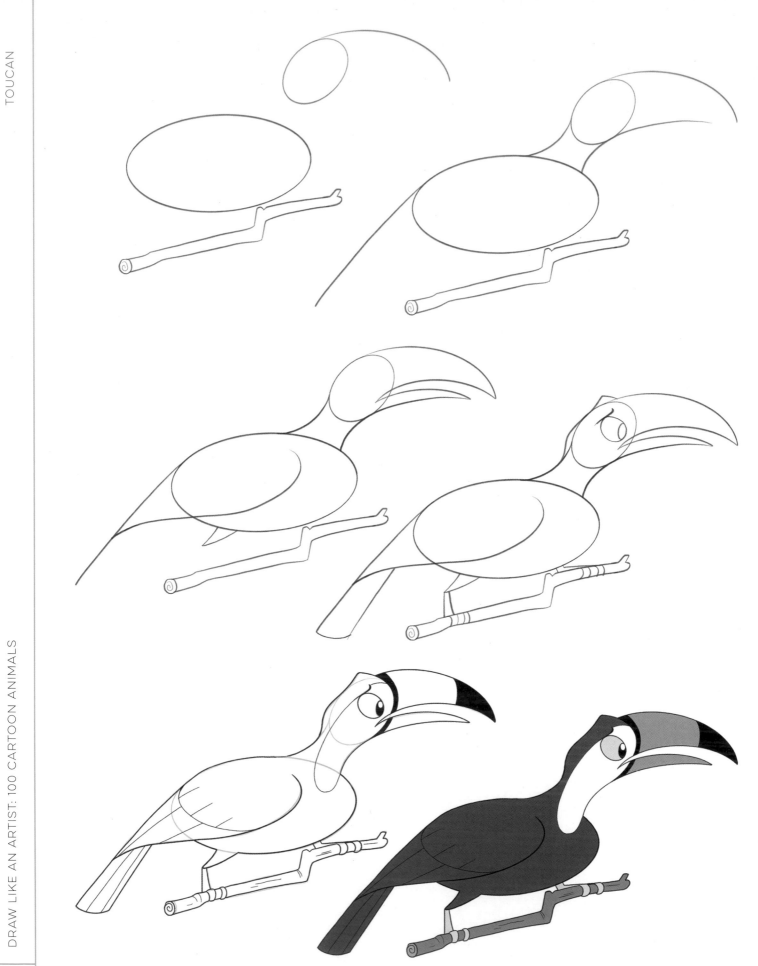

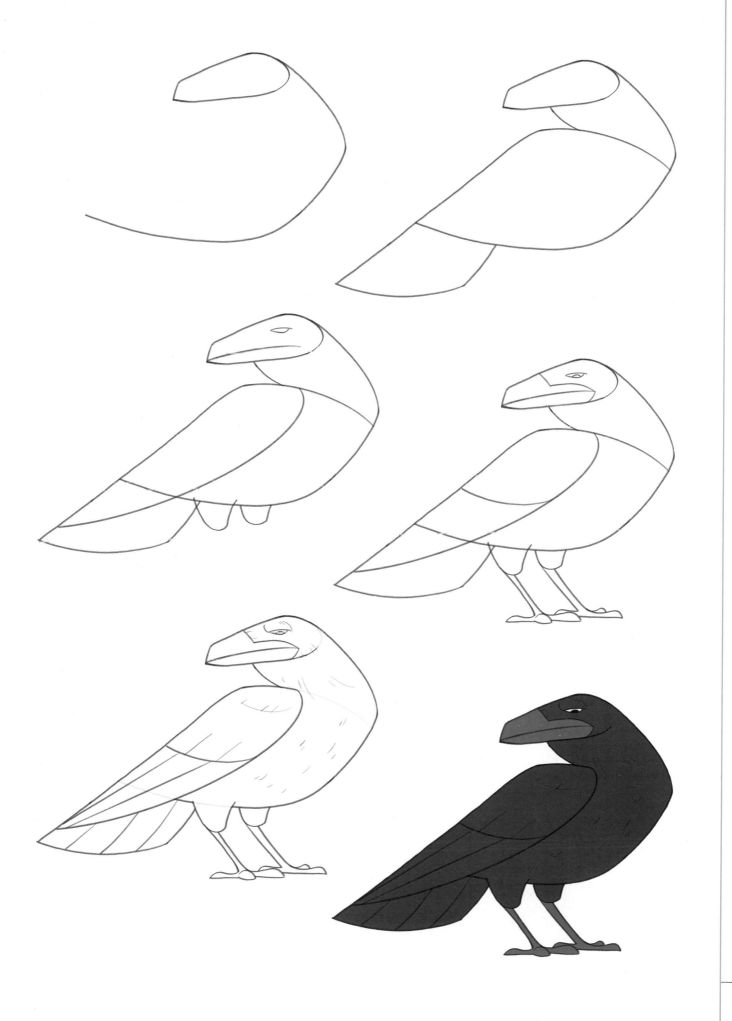

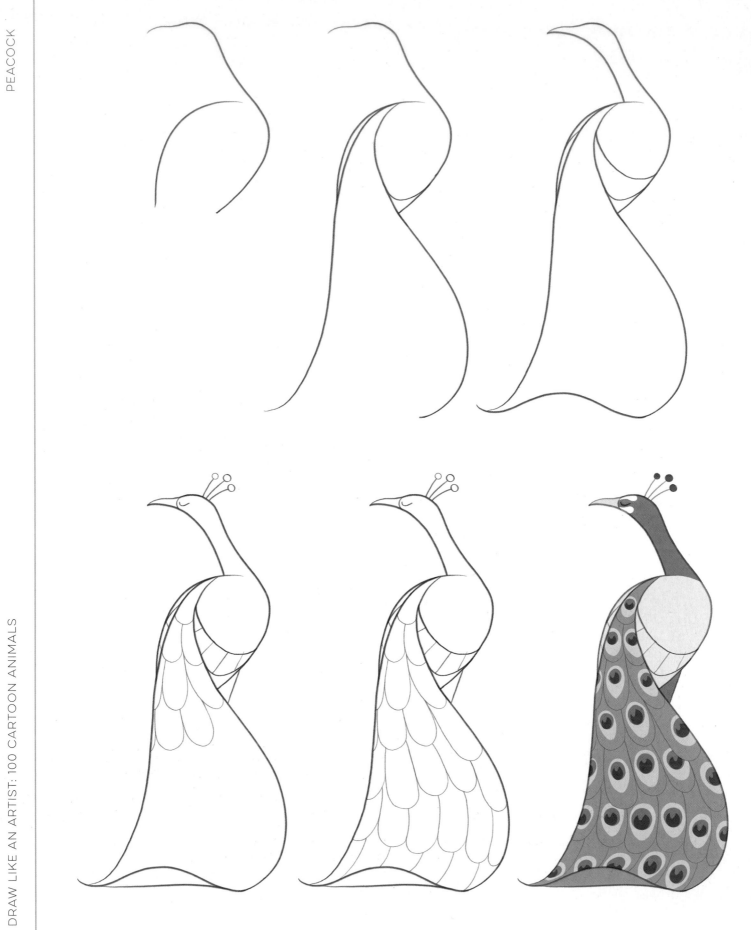

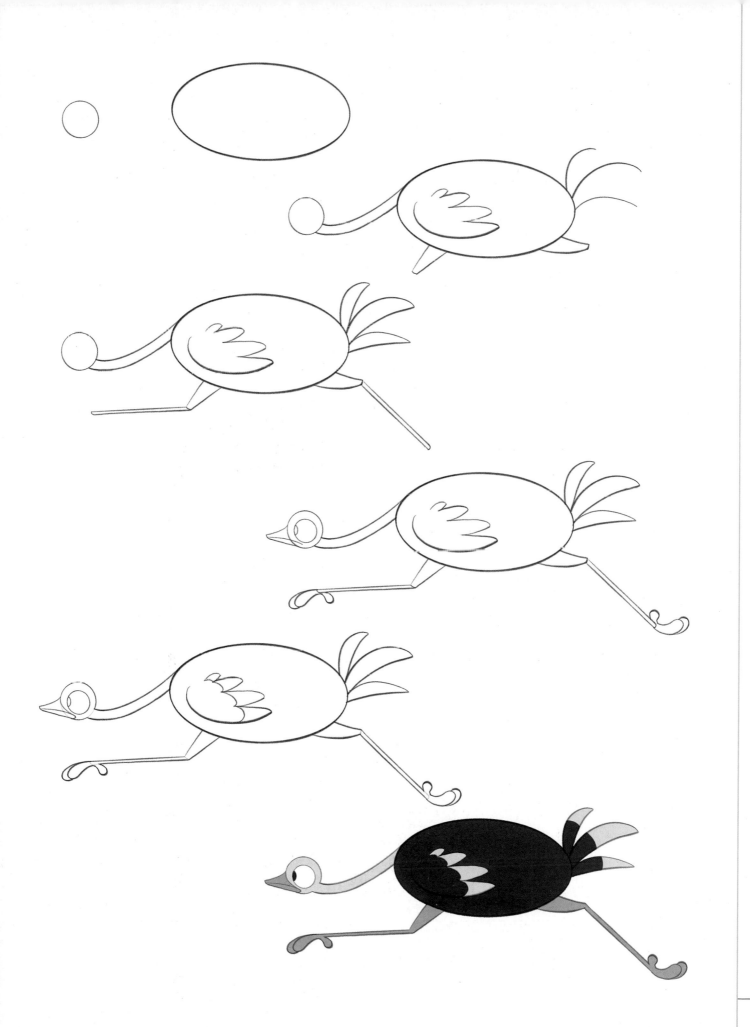

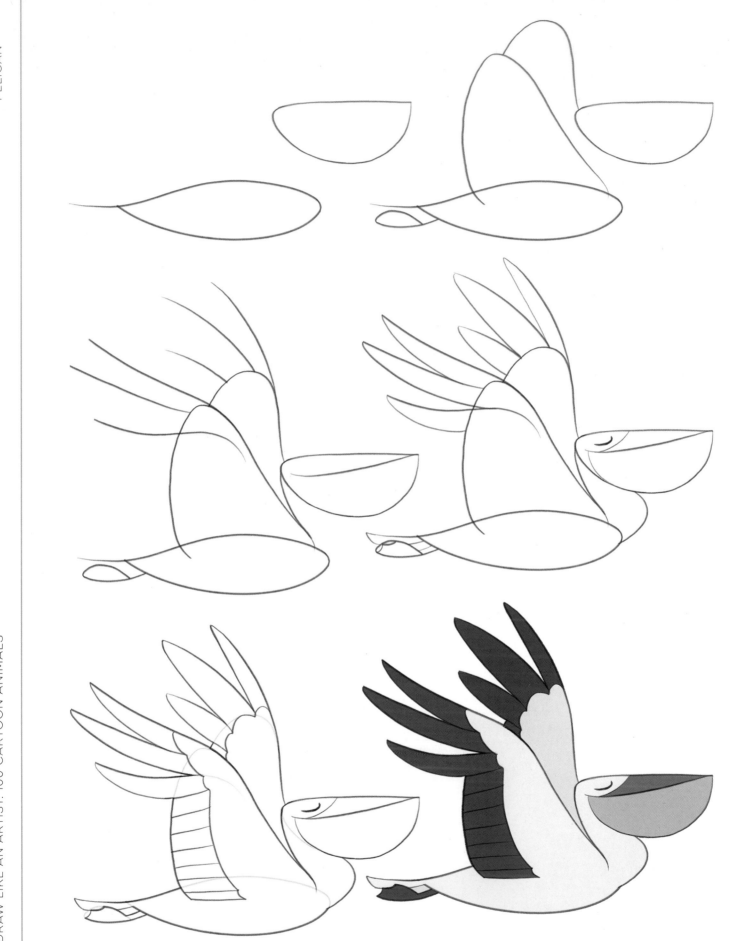

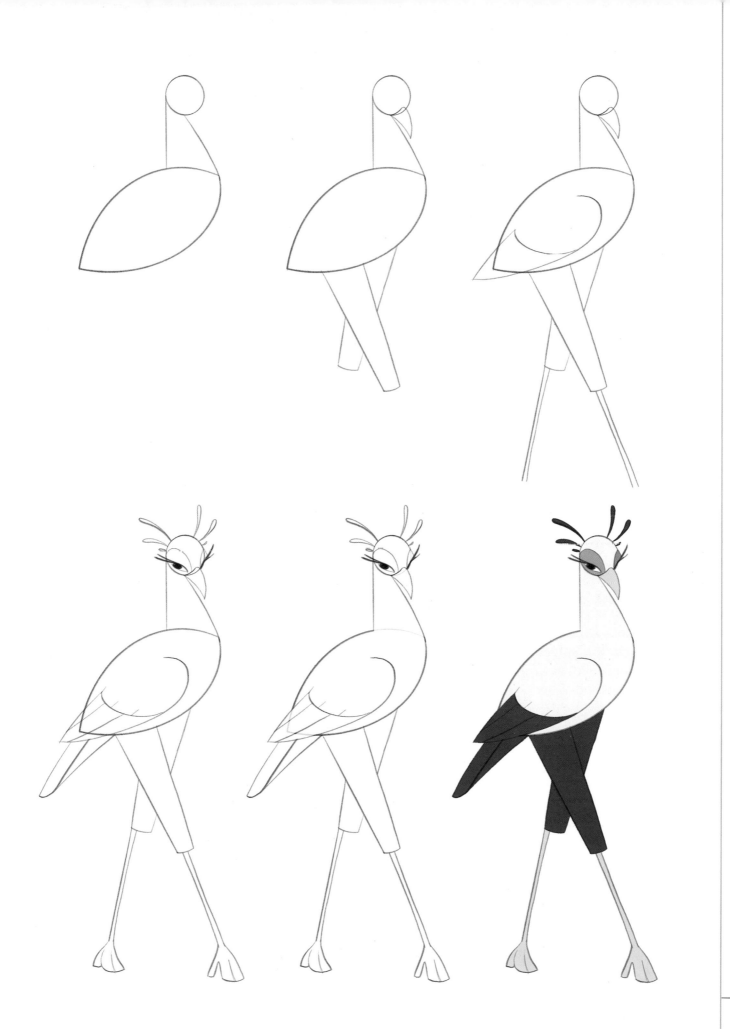

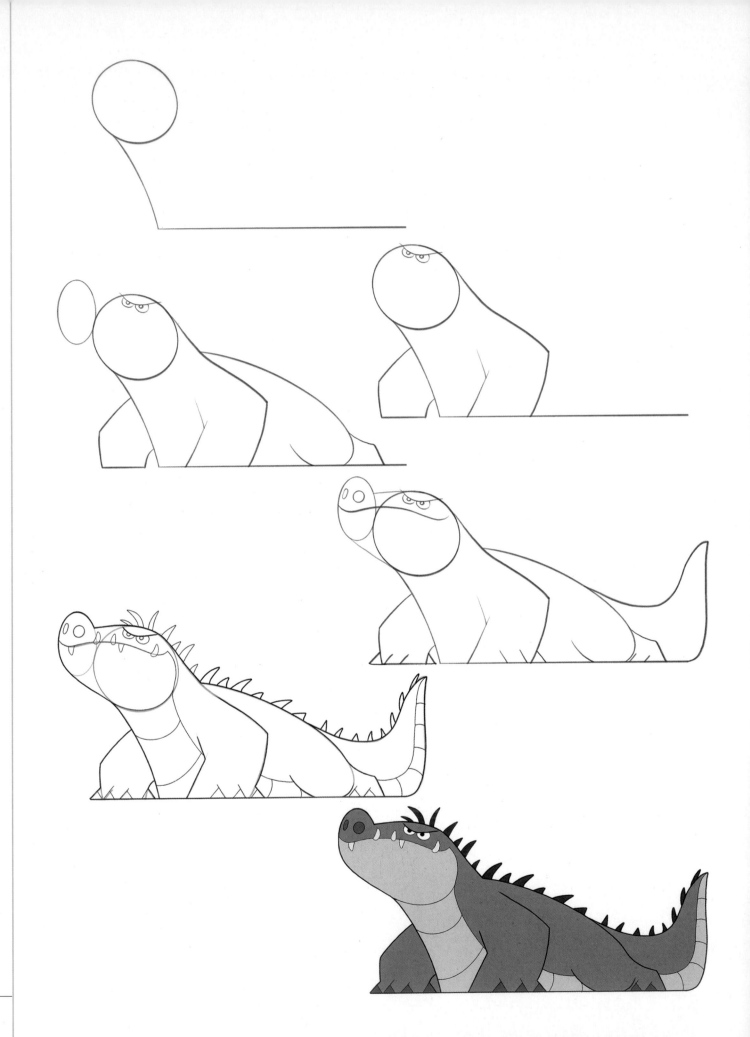

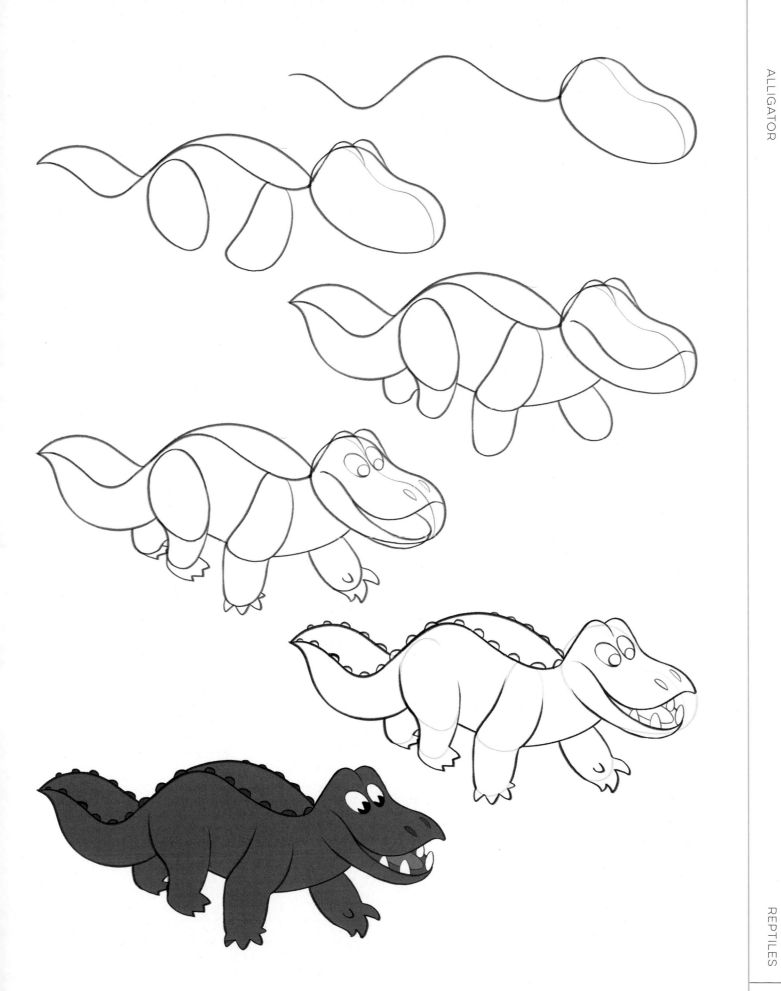

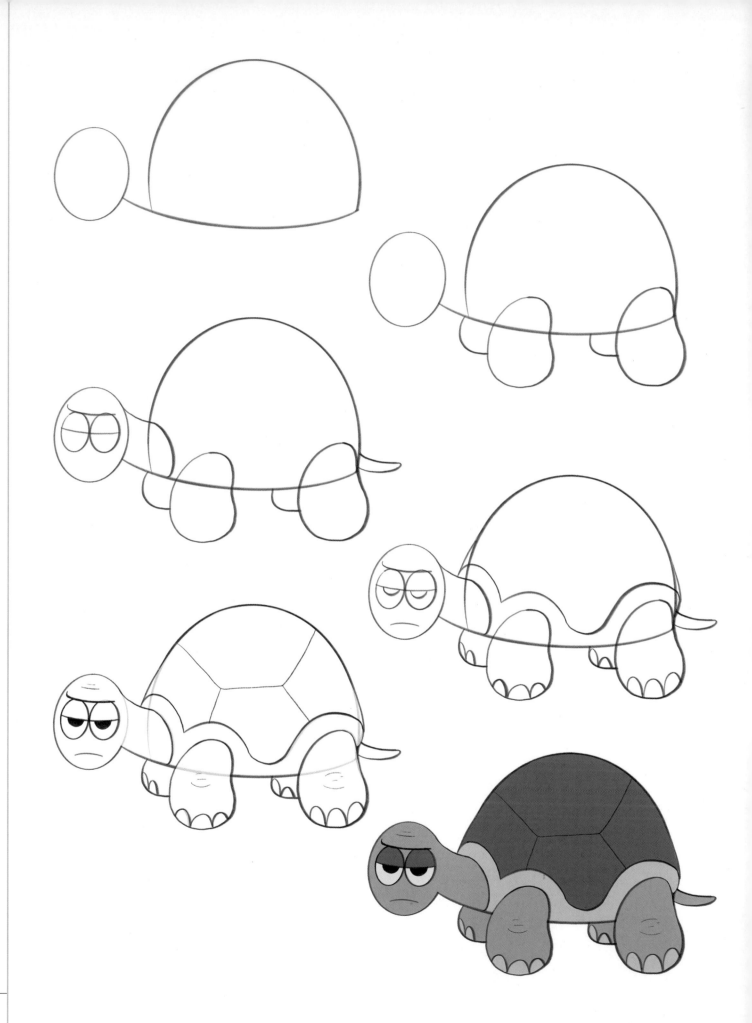

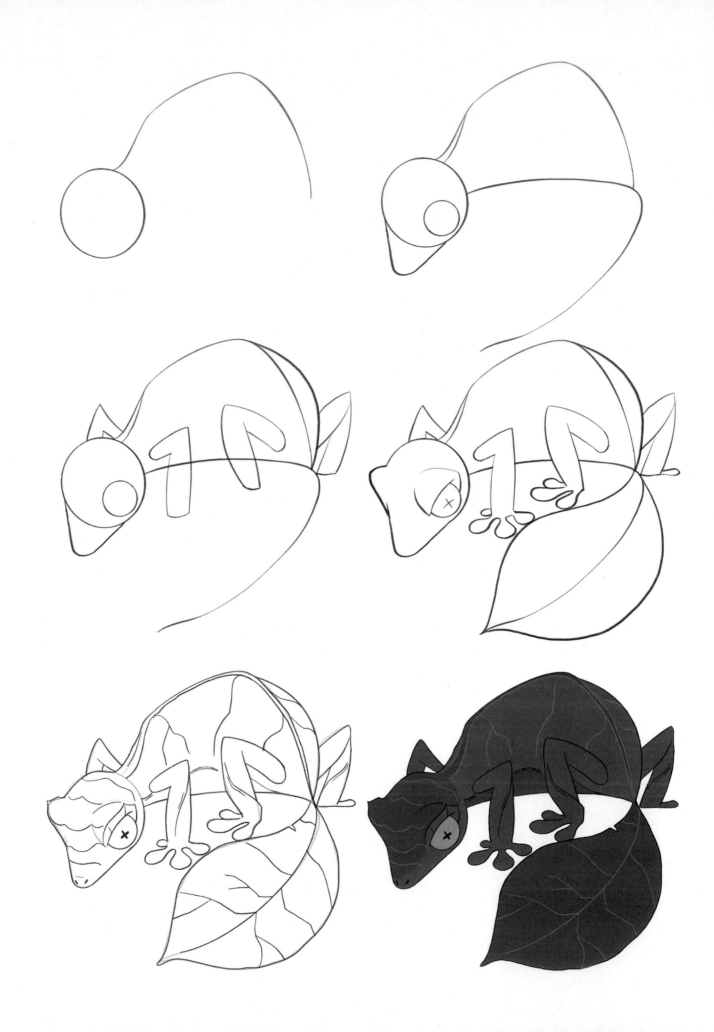

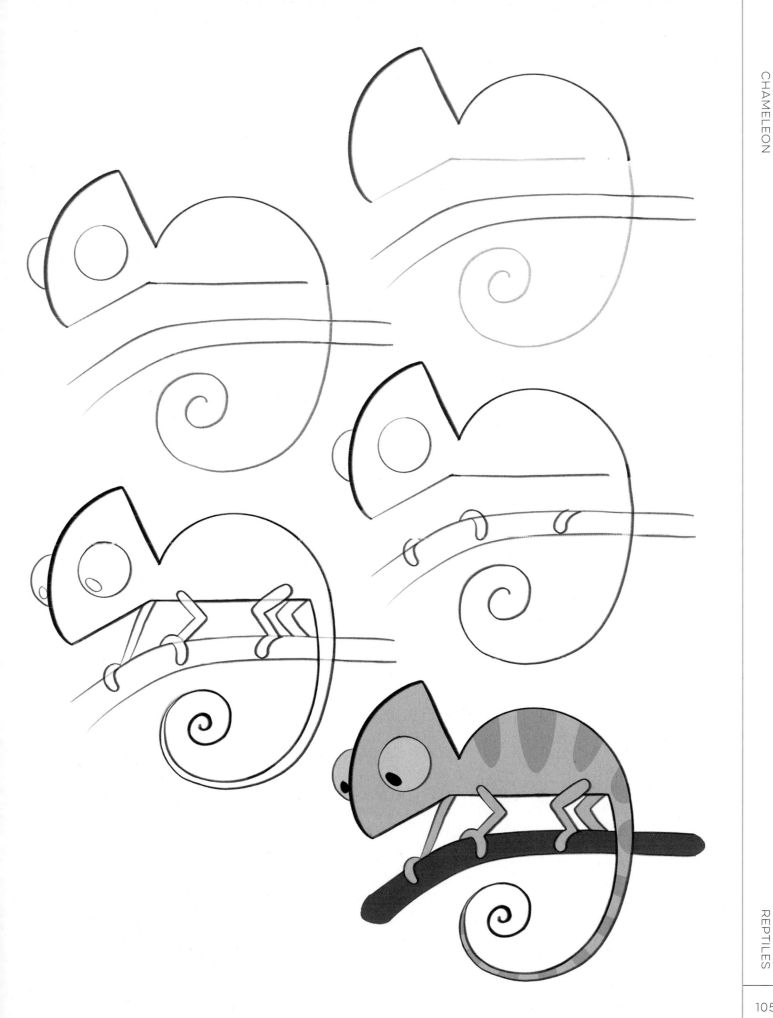

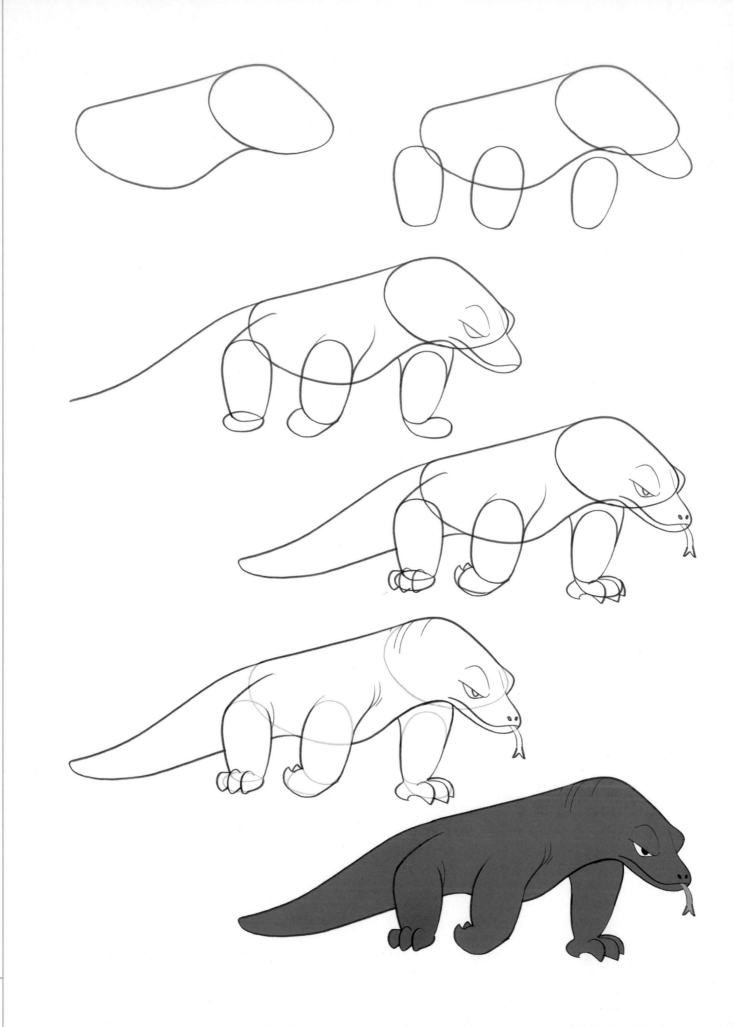

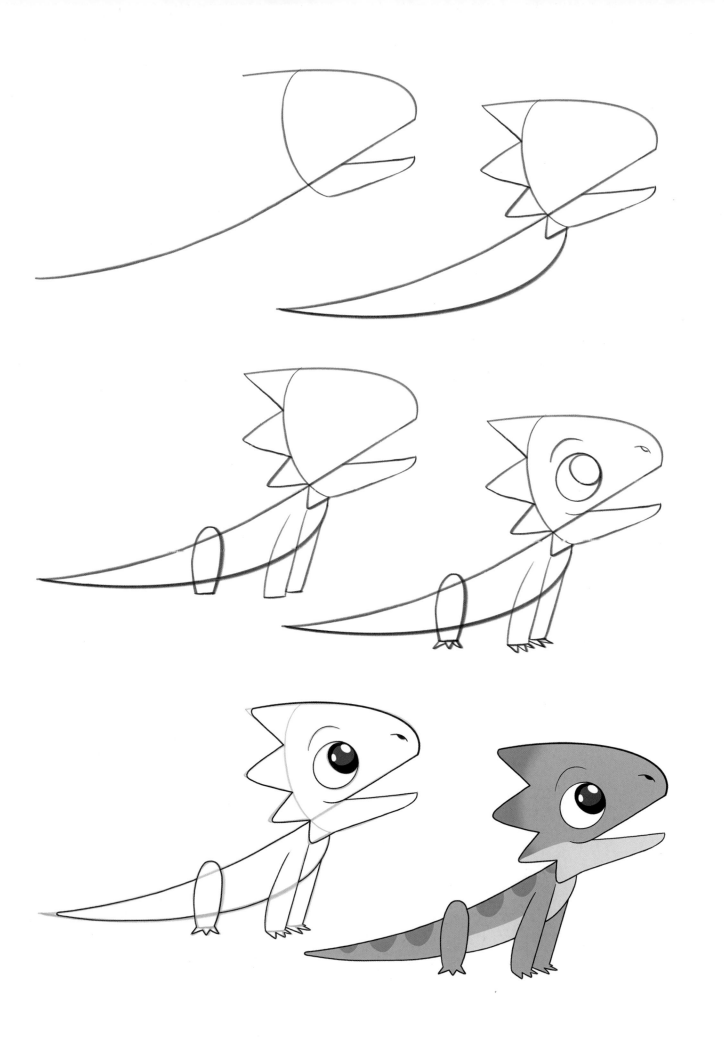

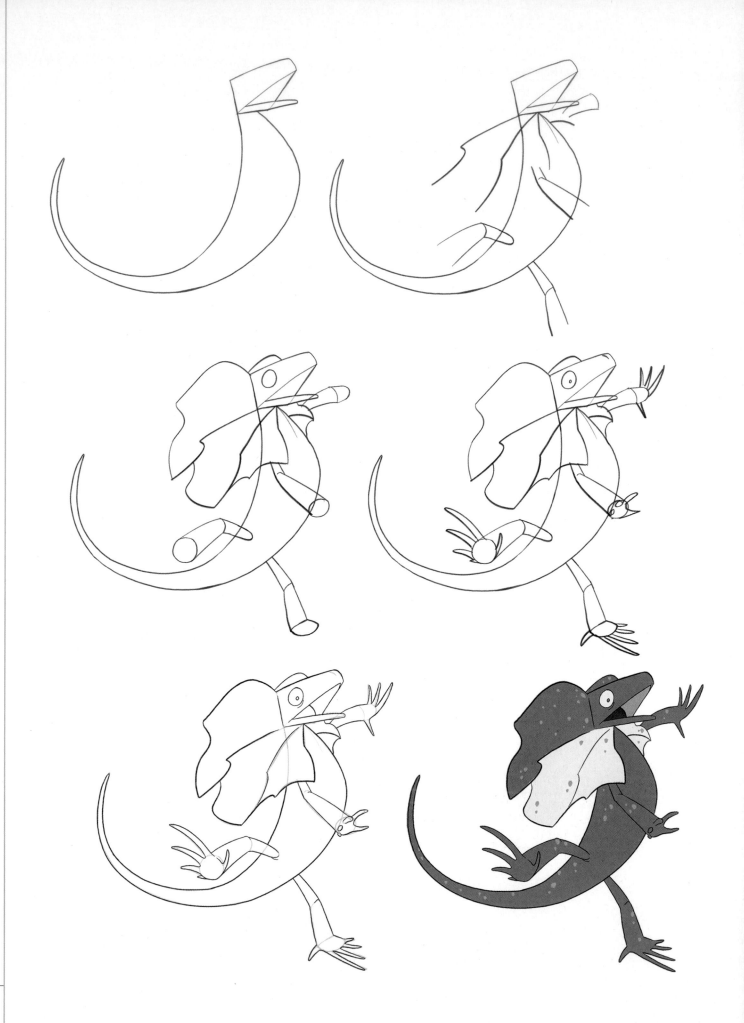

ACKNOWLEDGMENTS

I would like to express my most heartfelt thanks to Joy Aquilino, for granting me the opportunity to create this book, and to my art director Heather Godin, for her guidance and encouraging feedback.

Lilja Husmo and Sandy Scullion: Where do I even begin? This book was made almost entirely under their roof, fueled by their coffee, hospitality, and kindness following an international move home. Thank you, my dear friends, for opening your home to me and helping me to cross the finish line. Thank you to Rory Cheyne, not only for proofreading but also for your faith in my ability to rise to this challenge, and to Chloe Peters, for recommending me as a collaborator with Quarto.

I'd like to acknowledge my aunt Liz Fraser, for igniting my passion for drawing animals with that first trip to the zoo and providing me with all the art supplies and resources I ever needed as a child. And, finally, I must give my warmest thanks to my grandmother Jenny McMahon (1933–2019), for providing me with endless support, love, and encouragement—enough to sustain me for a lifetime.

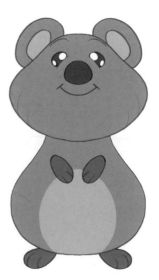

ABOUT THE AUTHOR

Keilidh Bradley is an independent animated filmmaker from Scotland. The creator of the acclaimed animated short film *Fox Fires*, Keilidh's work has been featured in many media outlets, including Digital Arts, Nerdist, and Bored Panda. A graduate of the Duncan of Jordanstone College of Art & Design in Dundee, Scotland, she also holds a Master's in Character Animation and Animated Filmmaking from Gobelins School of the Image in Paris.

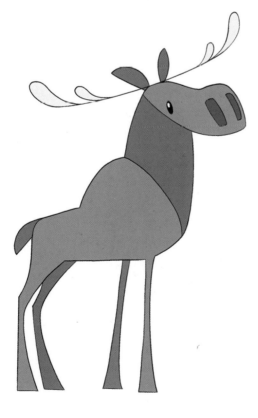

OTHER TITLES IN THE
DRAW LIKE AN ARTIST SERIES

Draw Like an Artist: 100 Fantasy Creatures and Characters
978-1-63159-964-4

Draw Like an Artist: 100 Realistic Animals
978-1-63159-819-7

Draw Like an Artist: Birds, Butterflies, and Other Insects
978-1-63159-947-7

Draw Like an Artist: 100 Flowers and Plants
978-1-63159-755-8

Draw Like an Artist: 100 Faces and Figures
978-1-63159-710-7

Draw Like an Artist: 100 Buildings and Architectural Details
978-0-76037-076-6